IMAGES
of America

BALDWIN COUNTY

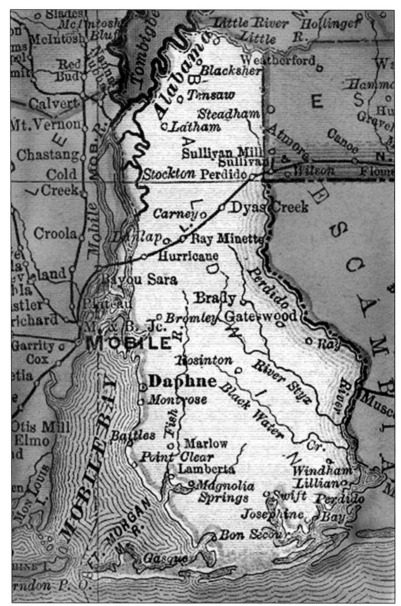

MAP OF BALDWIN COUNTY. The earliest maps of Baldwin County clearly show the importance of waterways in the development of the county. In the late 1800s, the Federal Road, going through Stockton was being supplanted by the rail line shown on the map. At the time of the map, Daphne was the county seat and was the primary landing for boat transportation across Mobile Bay. (Courtesy of Baldwin County Archives.)

ON THE COVER: This turpentine still is representative of the earliest manufacturers of turpentine, or naval stores, the primary product of the forest industry in the first part of the 20th century. Most of the earliest settlers came to Baldwin County for work in sawmills, lumbering, or turpentine and tar manufacturing businesses. The sap from pine trees was gathered and taken to the distilleries for processing into products used primarily in the shipbuilding industry in nearby Mobile. (Courtesy of Willison Duck Photograph Collection.)

IMAGES

of America

BALDWIN COUNTY

John C. Lewis and Harriet Brill Outlaw

ARCADIA
PUBLISHING

Published by Arcadia Publishing
Charleston, South Carolina

Printed in the United States of America

Library of Congress Control Number: 2008937344

For all general information contact Arcadia Publishing at:
Telephone 843-853-2070
Fax 843-853-0044
E-mail sales@arcadiapublishing.com
For customer service and orders:
Toll-Free 1-888-313-2665

Visit us on the Internet at www.arcadiapublishing.com

WILLISON DUCK. This book
is dedicated to the memory of
Willison Duck, photographer
and photograph preservationist.
(Photograph by John Lewis.)

CONTENTS

FOREWORD

Baldwin County's inherent natural beauty and abundance of natural resources first attracted European explorers to her shores over 300 years ago. Long before that, the Native Americans of the region thrived on the abundance of foods gathered from the land and the waters of Baldwin County. In the 19th and early 20th centuries, settlers from the far reaches of the expanding United States and the world discovered in Baldwin County their means of fulfilling lifelong dreams of owning land and carving out a place for themselves from the soil. And from that dream, Baldwin County's agricultural and timber industry grew through the hard work of Italians, Germans, Scandinavians, Greeks, and a host of other immigrants who came to make the area one of the most culturally diverse settings in the Southeast, or in the United States for that matter. Most of the communities within the county were established by those hearty immigrants who made this area their home. Today those same communities look back at their rich heritage with pride and with an understanding that they are in some ways unique.

The value of the past is not lost on the descendants of the early settlers of Baldwin County. And through the use of documentation and photographs, modern laymen and historians alike can piece together the story of our ancestors. This book offers the opportunity to look back into time in order to place images with the written accounts and oral histories that tend to fade with each passing day. Although photography is relatively new as a means of recording history, with the American Civil War era ushering in its use on a grand scale, it provides substance for the written word and dimensional value to the spoken word. In a modern world so dependent on visual cues, this work provides a glimpse into Baldwin County's storied and diverse past as a means of nourishing a love of local history by those already enthralled by its richness and to invite newcomers to experience all the cultural diversity that is Baldwin County.

—John Jackson
Director of Baldwin County Archives and History

ACKNOWLEDGMENTS

This book is a work to honor more than 200 years of Baldwin County history through the rich heritage of photography. A collection of photographs of the early 20th century was preserved by the tireless efforts of Willison Duck of Bay Minette. Willison took on the tasks of photographing rapidly disappearing structures in Baldwin County and of collecting family photographs for the purpose of preserving the stories of the people of Baldwin County. Unless otherwise noted, the images used in this publication are from the Willison Duck Collection. The authors are also privileged to work with other photographs of families of early settlers, who have been most gracious to provide images for this project. Throughout this book, the reader will note the names of families who have been fortunate enough to have a heritage of stories and pictures to share with our readers. This is a small way to ensure their preservation for posterity, and the authors sincerely thank these families. We especially owe our gratitude to research historian Perry Outlaw, who spent many hours verifying dates and details.

Most communities in Baldwin County have at least one historian who has collected and written down the stories of the town and its residents, as noted in the bibliography, and we highly recommend each of them. Many towns in Baldwin County have local history museums, whose staffs have been very accommodating. Each of these has been most helpful in developing this broad overview of the entire county. The authors sincerely hope this work will show the connectedness of the people in this vast county, as well as pay tribute to the families who made this home. We are also deeply indebted to Brooksi Hudson of Arcadia Publishing, who has been most diligent in her assistance with this project. It could not have been possible without her expertise and advice.

INTRODUCTION

From the earliest Native Americans who came for food to the residents of booming Baldwin County today, a pride in family roots is a thread that runs continuously through its people. Any time one gathers a group of residents, talk begins, and the universal questions are asked: "Where are you from? Who are your people? What did they do?" This pictorial journey will answer those questions so the reader will get to know new people and become reacquainted with old family friends. One may even discover a family relationship.

"Where are you from?" In conversation, the response to this question will not only be one's current residence but information on the family "home place" and also the country of family origin prior to immigrating. Native American bloodlines are proudly claimed, as is a connection to the earliest French and Spanish colonists on the shores in the 1600s. Pioneer roots in north Baldwin began early in the 1700s. However, most residents claim descent from 20th-century immigrants in one of the more than 20 distinct colonization communities. The immigrant heritage of these communities is proudly preserved.

"Who are your people?" This typical question is heard time and again in Baldwin. The answer builds trust and gives an understanding of one's honor. The story of the people is what has made the county what it is today, and by sharing family heritage, we share history. The family names are still reminders of a variety of homelands. Koehler, Malec, Marino, Guarisco, Allegri, Hastie, Weatherford, Weekes, D'Olive, Johnson, Malbis, and Malovich all evoke memories of the ancestors who came from foreign lands to build a life for their people.

"What did they do?" People are often more interested in ancestors than they are in current employment or family. This is a connectedness that brings them together, a pride in heritage. The original settlers came because of the rich timberland, and nearly all of the early industry was connected to the thick, abundant pine forests. As trees were cleared and the rich farmland was opened, farming became the primary source of income. After the railroad was completed through the county and a spur line was built to connect with the southern areas, land development companies began wooing settlers from afar with promises of cheap dirt: "A farm of your own in the most incredible environment imaginable." The people who built these towns are the ones who gave Baldwin County the heritage she has today: the people. This is the story of the people who came.

One

THE PEOPLE WHO BUILT THE COUNTY

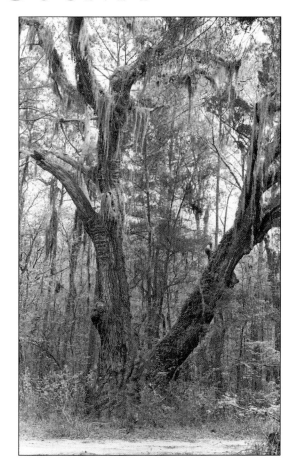

JURY OAK. By 1811, Blakeley was the site of the superior court with Judge Harry Toulmin presiding, sitting in the fork of the famous Jury Oak. The planned city, developed by Josiah Blakeley, was named the county seat after the county was extended all the way to the Gulf of Mexico. Damaged in Hurricane Frederic in 1979, the oak finally fell in 1992, at which time a memorial service was held. (Courtesy of Blakeley State Park.)

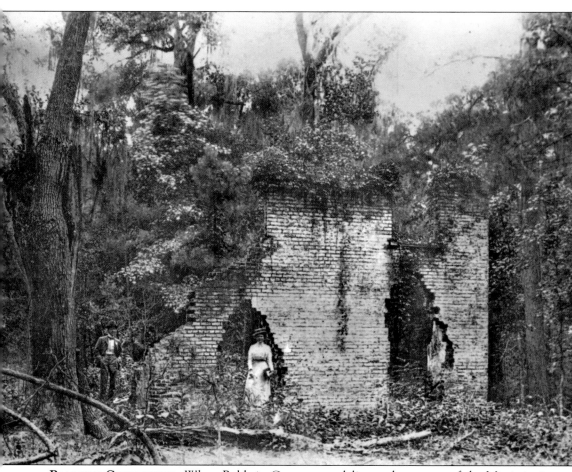

BLAKELEY COURTHOUSE. When Baldwin County was delineated as a part of the Mississippi Territory in 1809, the county seat was at McIntosh Bluff on the Tombigbee River, but it was soon moved across the delta to Blakeley. The Blakeley Courthouse was built at a cost of $2,000 in 1820. Blakeley was a thriving port town of 5,000 inhabitants with active newspapers, schools, merchants, churches, and beautiful homes. The yellow fever epidemics in 1826 and 1828, coupled with the high prices asked by speculators, led to the demise of the prospering town of Blakeley. Many of the homes from Blakeley were moved brick by brick across Mobile Bay and were rebuilt in downtown Mobile. Even though most of the population had moved away, Blakeley was still the county seat during the Battle of Blakeley in 1865, which was actually fought after Lee had officially surrendered. This photograph was taken in the 1890s, after the town of Blakeley had been abandoned and the courthouse had been moved to Daphne. (Courtesy of the University of South Alabama Archives.)

BLAKELEY MONUMENT. A tribute to some of the people of the earliest Blakeley days still stands in the Blakeley cemetery. It is speculated that the people named on each side of the obelisk were associates of Josiah Blakeley in founding the town. Dates listed are from 1819 to 1822. Most of the burials in this cemetery were a result of epidemics. (Courtesy of Blakeley State Park.)

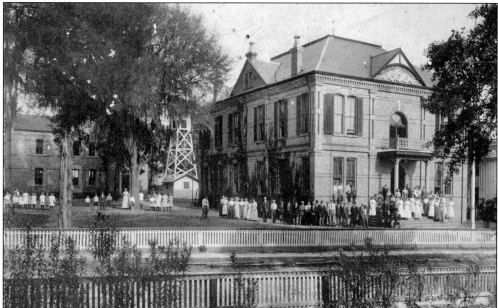

DAPHNE COURTHOUSE. Blakeley Courthouse was used until August 1868, when the Alabama Legislature moved the county seat to Daphne. The new courthouse was built for $18,000 near the Howard Hotel and docking facilities for the bay boats. The story of the move of the county seat to Bay Minette is one that still breeds intense emotions among citizens more than 100 years later. (Courtesy of Daphne Museum.)

GRAND JURY, 1897. The grand jury of 1897 is photographed outside of the jail, which stood next to the courthouse. A temporary courthouse facing Second Street had served from 1868 to 1887, until the two-story courthouse was completed. A marker in front of the site makes the statement, "1901—Court records stolen and taken to Bay Minette." (Courtesy of Daphne Museum.)

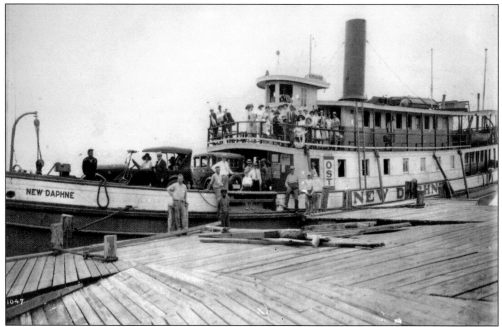

DAPHNE BAYFRONT DOCK. Daphne was the logical location for the county seat, as bay boats were the primary form of transportation to the port of Mobile, a major shipping point. The shallow-draft boats remained popular even after the onset of automobiles, as cars could be transported from Mobile and join points north and the Old Spanish Trail to Florida. (Courtesy of Daphne Museum.)

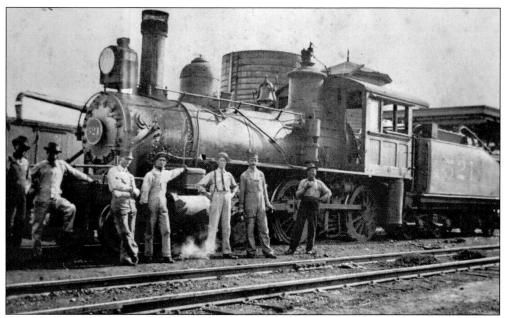

LOUISVILLE AND NASHVILLE (L&N) RAIL LINE. The railroad was a major factor bringing development to Baldwin County. The L&N line had been completed to the delta by 1860 but was not connected to Mobile until the 1870s. With improved facilities for travel and better connection to Mobile, the citizens in Bay Minette began action to have the county seat moved to their town.

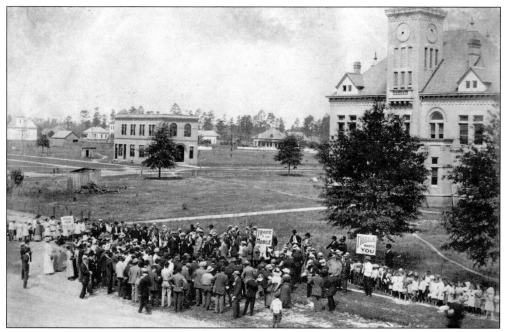

CAMPAIGN FOR COUNTY SEAT. Citizens in Bay Minette campaigned for the use of the rail lines as the primary connection to Mobile. The connection to Mobile made Bay Minette a more plausible location for the county seat, according to the proponents of the move. These citizens are urging people to use the rails to go shopping in Mobile.

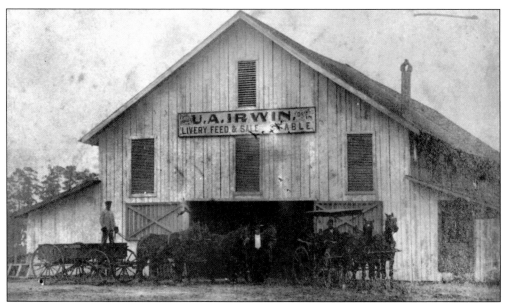

THE COURTHOUSE MOVE. The Alabama Legislature approved Bay Minette as the county seat in February 1901. By October, the courthouse was completed and ready for the records and furnishings; stories of the night the courthouse was "stolen" are lively and usually punctuated with passion, depending on the ancestry of the storyteller. Fifteen to 20 men hitched their horses to wagons leaving Bay Minette on October 11, 1901, armed with pistols and shotguns. Memories of E. J. Norris, who participated in the venture, were recorded in a 1956 article in the *Mobile Press Register*. He recalls that prior arrangements with Sheriff George Bryant in Daphne made the records exchange easy. Norris reports that they came into town after dark and a prisoner helped load the wagons; he was then transported to Bay Minette to become the first prisoner in the Bay Minette facility. The transfer took about five hours at the Daphne Courthouse, and the drive back took until the middle of the next day, October 12. Irwin's Livery Stable, in these photographs, helped prepare for the "raid."

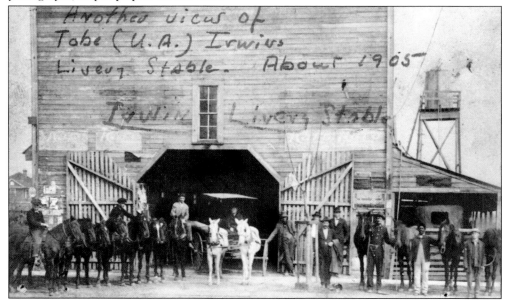

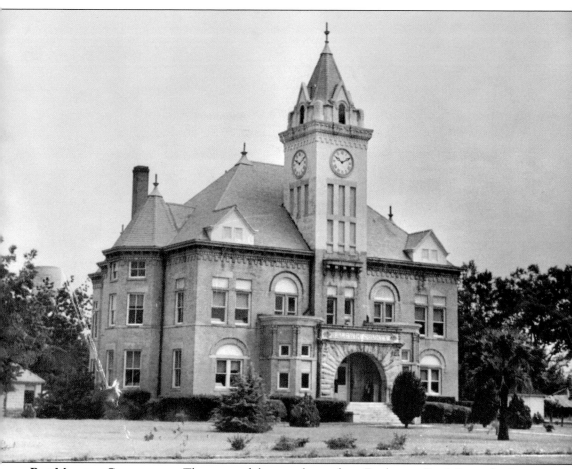

BAY MINETTE COURTHOUSE. The move of the courthouse from Daphne to Bay Minette begins before the actual move took place. Leaders in the town of Bay Minette had determined that their town would be a more effective location for the county seat than Daphne, now that the railroad line to Mobile was completed and rails were fast becoming a better means of transportation than the bay boats. Political leaders were successful in a request to the Alabama Legislature to have Bay Minette named the county seat in an act passed on February 5, 1901. The act required Bay Minette to build a courthouse with no tax increase and that Bay Minette must find a buyer for the Daphne Courthouse. When the new cornerstone was laid in July 4, 1901, there was a city-wide celebration in Bay Minette.

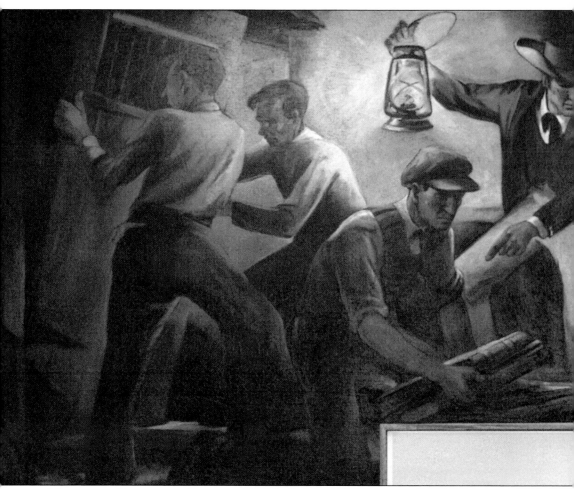

MOVING THE COURTHOUSE RECORDS. A Works Progress Administration (WPA) painting made in 1939 depicts the more dramatic account of the courthouse move. The painting, by Hilton Leech of Bridgeport, Connecticut, was painted under the government program in which artists were hired to depict local historical events for public buildings. The painting is based on an October 13 *Mobile News-Item* article stating that a group of men from Bay Minette went to Daphne and were

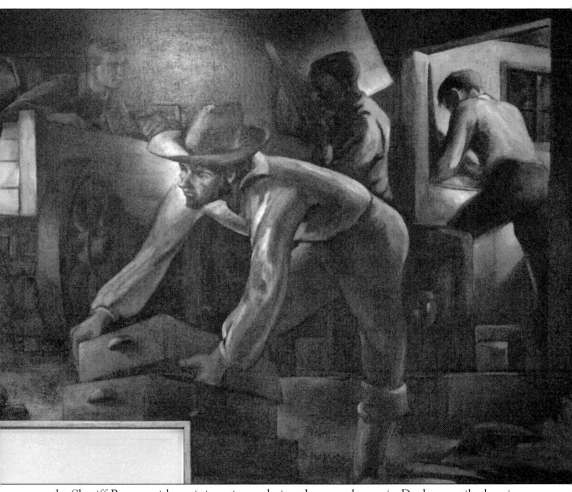

met by Sheriff Bryant with an injunction ordering the records stay in Daphne until a hearing. The paper reported that the men used deception to get into the courthouse and used force to seize the records, the jail cell equipment, and furnishings. The painting was executed as a mural on the wall of the Bay Minette Post Office. (Photograph by John Lewis.)

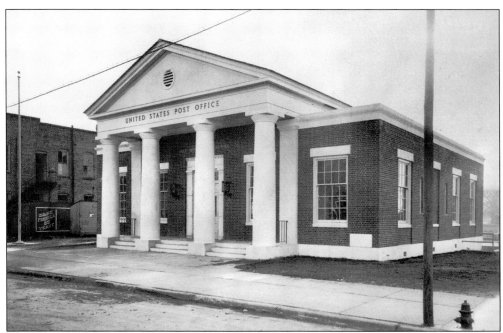

THE 1937 POST OFFICE. The WPA painting on the previous pages was painted on the walls of this post office, completed in 1937, which is currently the Bay Minette Utilities Building on Hand Avenue. When the post office on Highway 59 was built in 1990, the painting was removed from its original location and moved to its current location in the new post office.

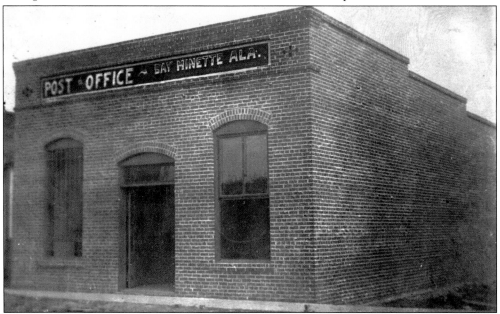

POST OFFICE, 1901. Florence Dinwiddie was postmistress in this official Postal Saving Depository located on the square. The first post office was on Railroad Street but was moved when the courthouse was built. One of the earliest photographs shows a banner in front: "Baseball Game Today." One resident remembers well a postmaster who was the only Republican in town, which invoked fear in many children.

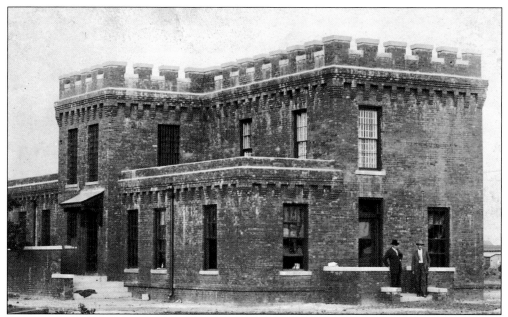

COUNTY JAIL, HAND AVENUE. At first, county prisoners were held in a small four-room jail on Hoyle Avenue. The bars and cells were moved to the upstairs of this new jail, built in 1910. In fact, the first prisoner in Bay Minette was actually transferred on the night of the move from Daphne. There are stories that he helped move the records as well. The jail shown above remained in use until 1985.

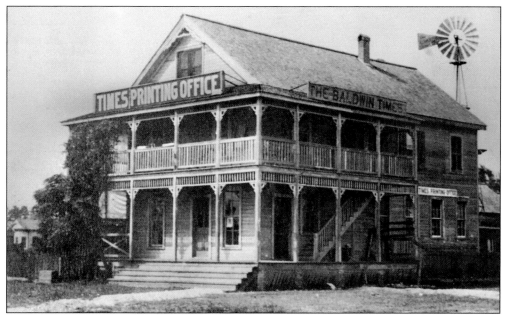

THE BALDWIN TIMES. The oldest continuous newspaper in Baldwin County was actually begun as the *Daphne Times* on May 26, 1890, by George Hoyle. In 1895, editor Abner Smith changed the name to the *Baldwin Times*, and the paper was moved to Bay Minette in 1901. After several other ownerships, the paper was sold in 1937 to Jimmy Faulkner, who served as editor for more than 50 years.

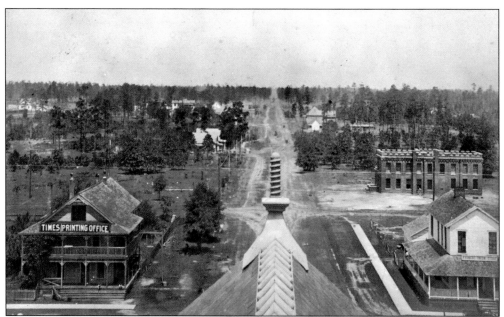

NORTH VIEW OF BAY MINETTE. The photographs taken from the tower of the courthouse are incredible images of the new but booming town. The view looking north shows the *Times* printing office on the left and the jail on the right facing Hand Avenue, named for J. D. Hand, one of the founders of the town. On the right is the Farmers' Union Store, a cooperative organization of farmers.

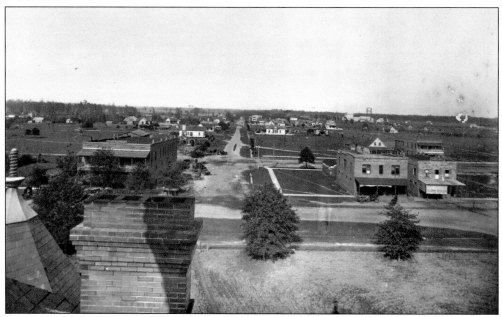

LOOKING EAST FROM THE COURTHOUSE. As the viewer turns clockwise, the east view shows Second Avenue heading toward Perdido. On the left is Mixon's Mercantile Store, a brick two-story general store with the name in the concrete facade. School was held in the upstairs of this building for several years. Note the outside privies and an early water tank. In the far distant right is the Newport Plant.

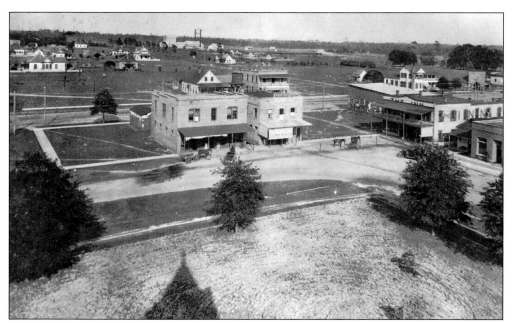

SOUTHEAST VIEW. This commercial corner was primarily two-story brick buildings with awnings shading the wooden sidewalks. The second building to the right bears the sign Baldwin Drugs, followed by a vacant lot, soon home to the Baldwin County Bank. The building in the corner was the Inn, and the Trammel Hotel is behind on Hoyle Avenue. The Inn was later Bruce's Store, owned by Bruce Beveridge.

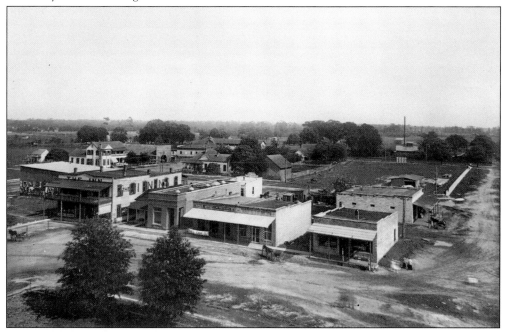

SOUTH SOUTHEAST VIEW. The next building was a café and later a movie theater, followed by the post office. In the distance are the depot and Erwin's Livery Stable, pictured on page 14. The corner building on Hand Avenue is best remembered as Lambert's, but here it is a barbershop and bathhouse, as indicated by the barber poles and signs for 25¢ baths.

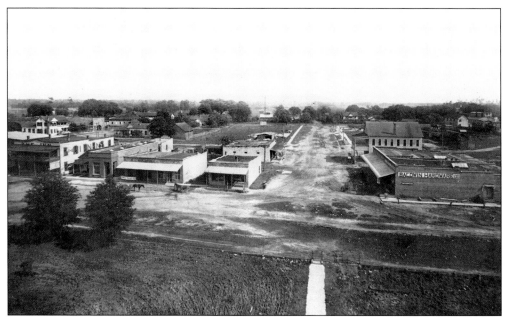

SOUTH FROM THE COURTHOUSE. Kahaley's Store, seen behind the corner barbershop, represents the success of several businessmen of Lebanese background. A 1920 newcomer speaks of the wonder of Kahaley's Dry Goods, where her "mother bought a tan Georgette blouse." The Nassars and the Haynies were other successful business owners. Across Hand Avenue is Baldwin Hardware, the large brick building on the corner.

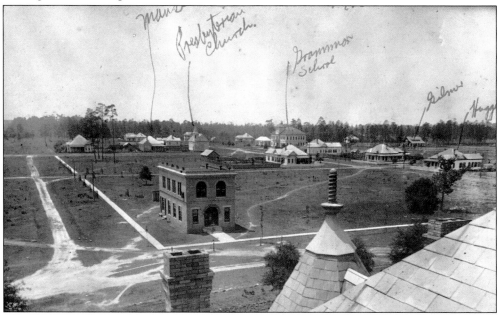

WEST NORTHWEST. Looking west, the Baldwin County Bank is seen, later becoming the location of the Masonic Lodge. The two-story school with the cupola is the Bay Minette High School. The bell took 25 horses to lift into the belfry and could be heard for 3 miles around. The Duryea home is visible in this photograph, labeled "Gilmer," the family home of Hampton Ewing, the owner of the Bay Minette Land Company.

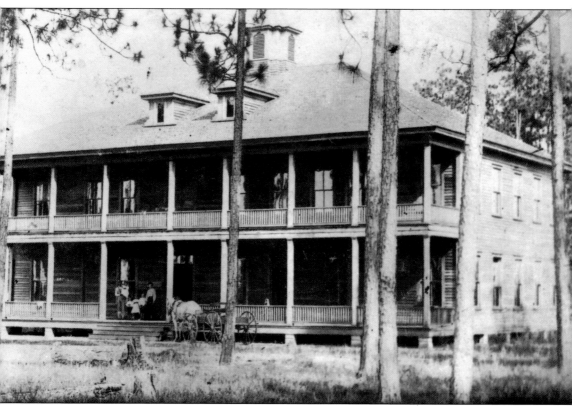

ALABAMA INDUSTRIAL COLLEGE. Located just outside of Bay Minette on a tract of 80 acres of land was the Alabama Industrial College. In *Bay Minette*, a booklet published by the Bay Minette Land Company in 1908, the industrial college is defined as being under the guidance of the Alabama Conference of the Methodist Episcopal Church, opening in 1908 with a large endowment. Even though called a college, the course of study was for all ages in academics, with specialized instruction in the industrial arts and sciences and in agriculture. It served as well for offices of the agricultural and home demonstration agents of the state of Alabama and as meeting rooms for training in agriculture for local farmers. It was located just north of Bay Minette on County Road 61. The building was abandoned in the 1920s but was still seen in the 1930s.

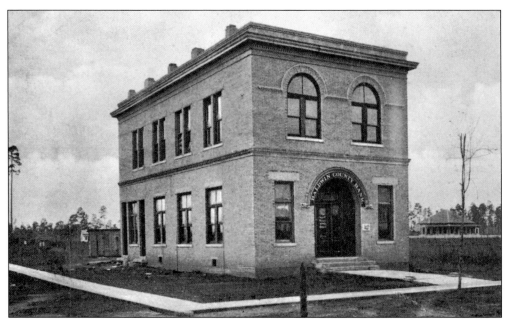

BALDWIN COUNTY BANK. One of the first successful businesses was the Baldwin County Bank. This building, in 1901 located on the west side of the courthouse, was moved to the southeast corner of the square in 1913. The bank, incorporated by J. D. Hand, was successful until the Depression, when it failed. It was soon revived, and a 1939 advertisement claims more than $408,000 in secure resources.

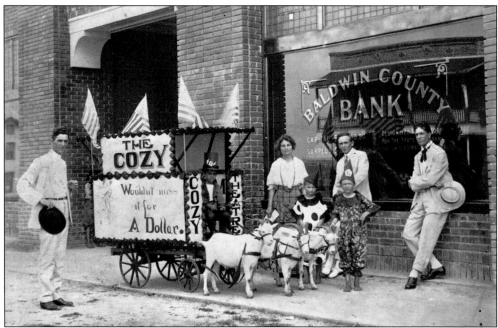

COZY THEATRE. The courthouse square naturally became the center of all activity in town, and this photograph of the Cozy shows children in costume for a dramatic production at the town fair. The courthouse square made a perfect parade route, and the grounds of the square were used for many public events, such as band concerts and pageants.

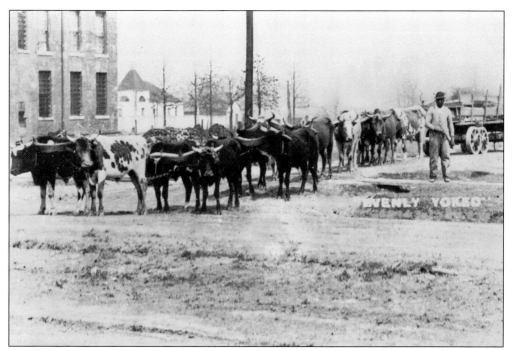

Oxen Team by the Jail. Dirt streets and oxen were the mode of the day. The jail in the background gives the location of this photograph as Hand Avenue. The driver is hauling lumber from the mill for a delivery.

Judge Hall Home. The street facing the railroad was the location of some of the earliest homes in Bay Minette. Judge Charles Hall, the probate judge in Daphne, had participated in the legalities of the courthouse move, and he personally supervised the moving of his desk and records to Bay Minette. He had a home in Daphne and also this home on First Street in Bay Minette, known for its hospitality.

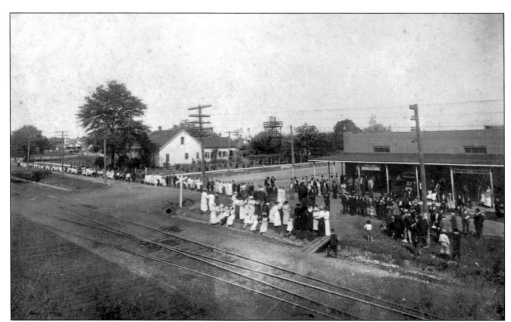

RAILROAD STREET. The depot was located on the south side of the tracks, where the first homes and businesses were located, but when J. D. Hand had the town replatted, donating the land for the courthouse on the north side of town, the center of business moved. Railroad Street still housed the first businesses settlers would seek. The Bay Minette Land Company was located here, as were several boardinghouses. People gathered to watch the train come in and meet visitors and new residents. The big event of each night was the 10:10 passing through. The author of *A Nickel's Worth of Baloney*, Harriet Brill, states that if the train came through sideways, it would have killed half of the population. "If some of us were 'out,' we would go to the depot and watch the passengers get on and off. It was a real thrill." The top photograph is a 1905 gathering of people waiting to see President Roosevelt's train pass through.

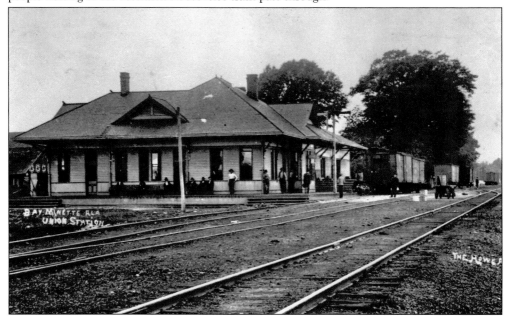

Two

THE PEOPLE WHO CAME TO NORTH BALDWIN

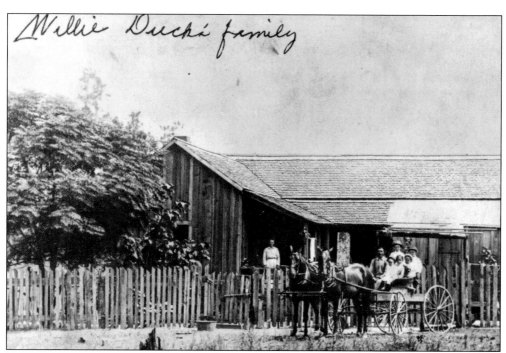

WILLIE DUCK FAMILY. The north Baldwin area was among the earliest developed in the county, with pioneers and plantation owners building homes and businesses long before the county was formed. The Willie Duck family poses at the front of their home in Stockton, a typical rural house of the 1800s. Like most of the inhabitants of the Tensaw settlement, the Ducks made a living from the rich pine forests.

EARLE HOME, BLACKSHER. At the north end of Baldwin County are the communities of Little River and Blacksher, settled in the late 1700s by English and Scotch families, many who had been granted land. They called the community Montpelier after the fort nearby. The name was changed to Blacksher when the Blacksher brothers built a post office. Pictured are James Manuel Earle and his wife, Laura Boyles, who built this double-pen-style log cabin with cypress tree trunk supports about 1815, shortly after the Fort Mims Massacre. Their first home, built in the 1700s, was burned in the uprising, during which they took shelter at Blakeley. The Earle family has passed down through five generations living in this house the story of Andrew and Rachel Jackson staying here. The Tate house, Montpelier, is also recorded as a residence of Andrew Jackson during his time in Baldwin County. While they were here, Rachel wrote of the "vast and howling wilderness" of the area. Jackson wrote his resignation from military service while staying here. (Courtesy of Smith-Earle family.)

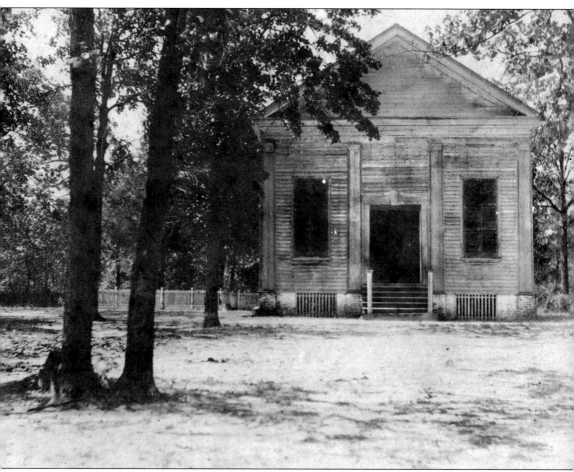

Montgomery Hill Baptist Church. The community now known as Tensaw was first settled in the late 1700s and was called Montgomery Hill. The Montgomery Hill Baptist Church, organized in 1854 and recognized as the oldest active Baptist church in the county, was built in Greek Revival style with wooden pegs at a cost of $1,400. It has a balcony commonly known as the "slave gallery," and the original pine pew seats are still in use. The churchyard cemetery is the resting place of the first families to call this place home. A wonderful story was told by Thomas Earle Sr. In the 1890s, an escaped convict hid in the attic of the church for several months. He foraged farms at night for chickens and smoked hams until the missing items prompted a sincere search and he was discovered. (Courtesy of Mark McGuire.)

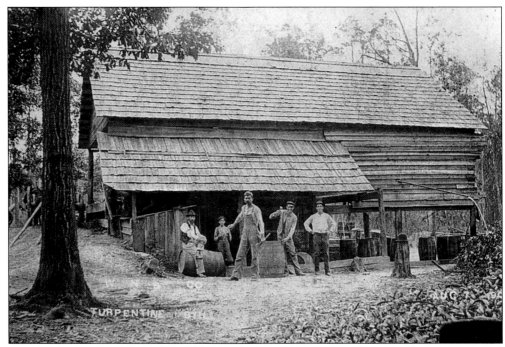

WILSON'S TURPENTINE STILL. John T. Wilson built several businesses based on the turpentine and sawmill industries. Wilson's Turpentine Still and Naval Store, pictured here, was in Blacksher. Wilson and some of his children are pictured on August 7, 1909. (Courtesy of Carolyn Dickinson.)

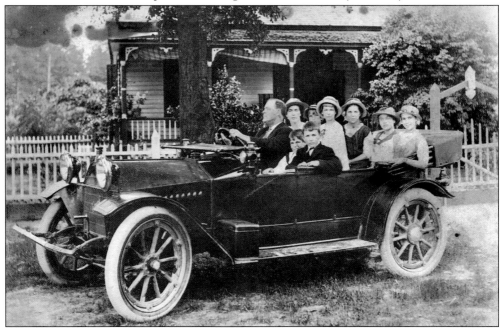

FIRST CADILLAC IN BALDWIN. John Wilson was on the cutting edge of innovation, purchasing the first Cadillac in Baldwin County. He and eight of his children are parked in front of the Wilson home on Highway 59. He also kept a car in Mobile for his frequent business trips there, where he stayed at the Battle House Hotel on a regular basis. (Courtesy of Carolyn Dickinson.)

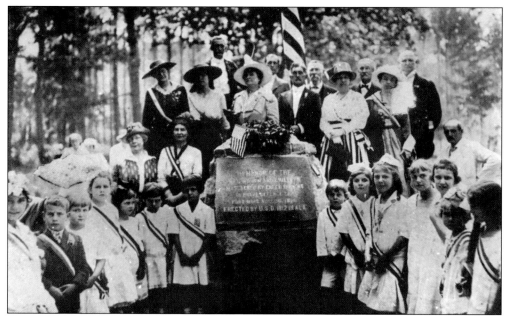

FORT MIMS MARKER. The United Daughters of 1812 place a 1917 monument at the site of the Fort Mims Massacre. The Alabama state historical marker reads, "Here in Creek Indian War 1813–1814 took place most brutal massacre in American history. Indians took fort with heavy loss, and then killed all but about 36 of some 550 in the fort." Reenactments take place here each August. (Courtesy of Tom Sangster.)

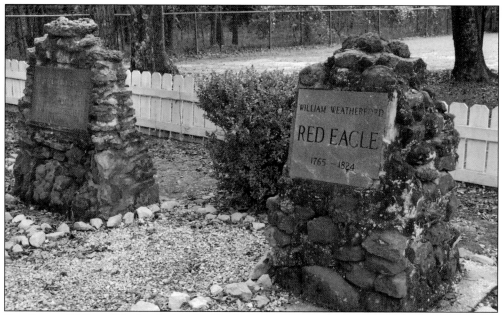

RED EAGLE. William Weatherford, or Red Eagle, led the Red Stick Creeks during the Creek Indian uprising, including the attack on Fort Mims. He later became a successful plantation owner in North Baldwin and good friend of Andrew Jackson. In 1824, he was buried here near his mother, Sehoy. The site is designated as the William Weatherford Memorial Park by the Baldwin County Commission. (Photograph by John Lewis.)

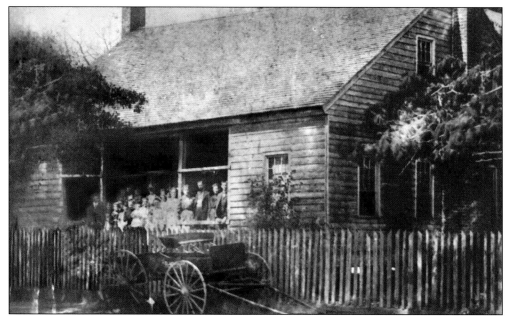

HAMMOND HOUSE INN. The Federal Road was most active during the 19th century. The John Hammond house in this photograph was the stagecoach inn in Stockton, operated by the Hammond family from 1860 to 1900. A road also ran south to the Hurricane-Crossroads community through Bromley and on to Blakeley. Blakeley connected to Mobile by boat and to Pensacola by the Wired Road. (Courtesy of Tom Sangster.)

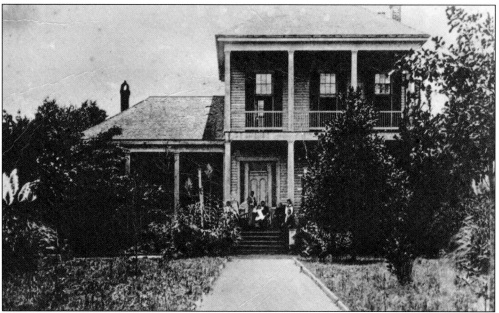

HASTIE HOME. The Ellicot Line runs through what is today Stockton on the Hastie property. The line, at the 31st parallel, was the dividing line between U.S. territory and Spanish Florida. Stockton, located just north of Interstate 65 on Highway 59, is the site of this Hastie family home. Dr. J. H. Hastie's home here housed his medical practice in a small office at the side yard. (Courtesy of Davida Richerson Hastie.)

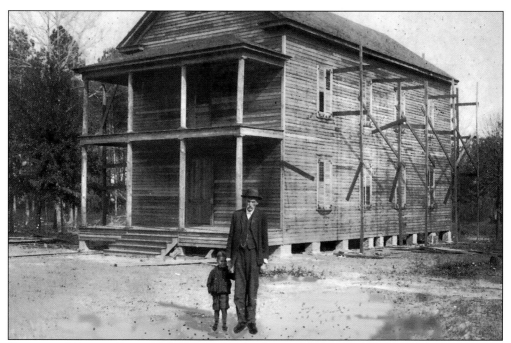

STOCKTON MASONIC LODGE. The charter of the Masonic lodge shown here was first at Blakeley and moved to Stockton when members relocated north. In 1865, the sword and charter were taken from the lodge by Union troops, but they returned in 1878. Pictured above is the 1924 lodge under construction after the original building burned. Pictured are Ed Richerson and his grandson, W. M. Richerson. (Courtesy of Davida Richerson Hastie.)

AMISH FAMILY HOME. In 1906, Eli N. Beachy and several other Amish families from Ohio bought acreage east of Bay Minette in the "Perdido Country" on Philipsville Road today. Beachy and his son Noah built the Pleasant Grove School for the community in 1909. After severe hurricane damage in 1915 and 1916, only five families remained, and in 1919, the Beachy family returned to Ohio. (Courtesy of Shirley Propst.)

PERDIDO DEPOT. The depot was the center of life in Perdido, just northeast of Bay Minette, remaining active until 1950. As rails spurred immigration, this area was the destination for many Czechoslovakian, Croatian, and Polish colonists who farmed and lumbered using the Perdido mills and shipping facilities, which were numerous. Neighboring farming communities of Halls Fork, Rabun, Lottie, and Dyas fed to Perdido for business. (Courtesy of Thursea Long.)

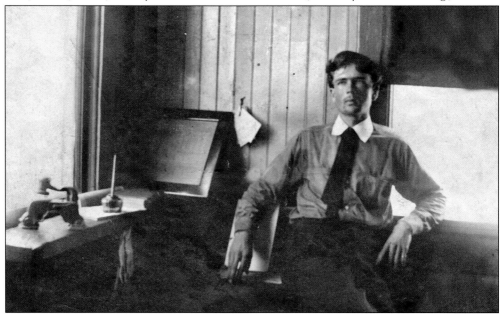

INSIDE THE STATION OFFICE. Pictured here about 1910 is LeeRoy Weekley, the station master for the L&N Railroad in Perdido for many years. Three brothers were station masters for the rail at the same time, LeeRoy at Perdido, John Weekley at Atmore, and Grover Weekley at Bay Minette. (Courtesy of the Long family.)

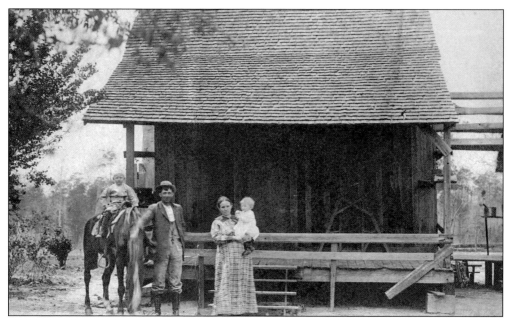

DYAS FARM HOUSE. The community of Dyas, just north of Perdido, was the destination of at least 11 families who emigrated from Croatia, coming directly here through Ellis Island. One of the families was the Malovich family, who spoke Croatian at home for the entire 20th century. The Croatians were Roman Catholic, but there is no record of a Catholic church in this area. This home is the Thomley home in Dyas in 1890. (Courtesy of the Long family.)

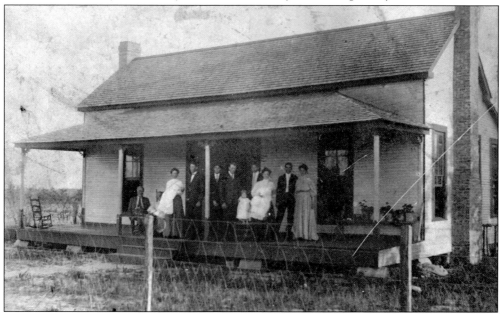

WEEKLEY FAMILY HOME. The communities surrounding Perdido were established because of the timber in the area, but families in town, represented by the Weekley family here, relied on town businesses for income. The community had two doctors, a pharmacy, two grocery stores, and a beauty shop. Pictured are the Weekley brothers, who worked for the Louisville and Nashville Railroad, and their families. (Courtesy of the Long family.)

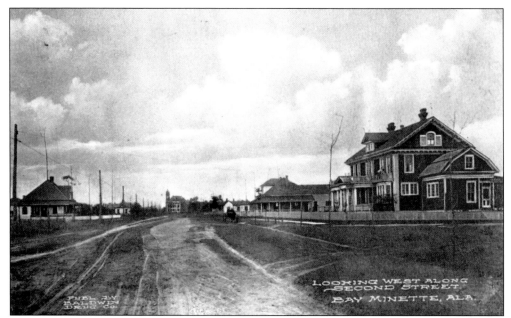

HAND RESIDENCE, BAY MINETTE. Coming in to the county seat from Perdido, the view would have been much like the one above heading toward the courthouse. On the right on Second Street is the Hand residence, built for Mattie Webster Hand about 1910. J. D. Hand initiated the incorporation of the city in 1906, but the town was originally settled farther south on the Bay of Minette, thus the name of the city.

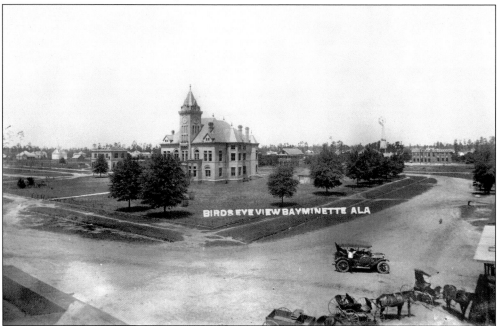

COURTHOUSE FROM BAY MINETTE INN VERANDA. The town underwent a building boom during the first decade of the century, and soon this lonely scene was the bustling center of county life, especially legal functions. Located at almost the geographic center of the county, it was a strategic location, as most of the population was in the north part of the county.

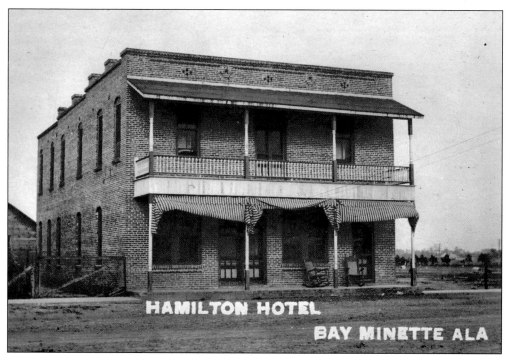

BAY MINETTE HOTELS. A 1922 publication by P. W. Sharp in Foley extolling the virtues of Baldwin County claims that the Trammel Hotel in Bay Minette, pictured below, was one of the best patronized and most widely known hotels in southern Alabama. It was owned by Louis Smith, who made a wonderful success of the property "located at the railroad junction, where train connections with Montgomery and points north, Pensacola, Florida, Mobile to the west, and Foley to the south." The hotel advertised hot and cold water, bath, all modern conveniences, and a cuisine second to none, with the slogan, "The Home of the Commercial Travelers." The Hamilton Hotel (above) is still standing on Hoyle Avenue, a wonderful example of two-story brick structures of 1910.

BAY MINETTE SANITORIUM. The distinctive architecture of this hospital is mysterious in origin. Dr. C. J. Campbell and Pearl Campbell operated the facility, which housed a resident wing for institutionalized patients as well as hospitalization rooms for illnesses. The building was located on Railroad Street and burned on May 5, 1908, with the unfortunate loss of two female residents.

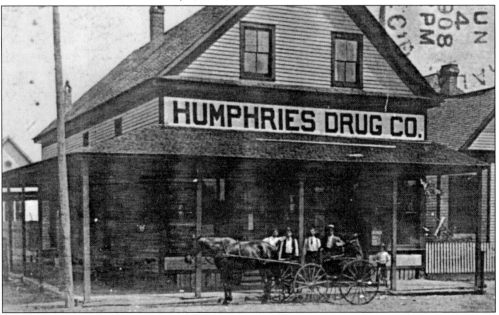

HUMPHRIES DRUG COMPANY. The earliest pharmacy in town was on Railroad Street and was built in 1890 by a Mr. Chute. Sam Sowell is recorded as purchasing the building, which was used as several types of stores. The building was moved by rolling it on logs to Pine Street, where it became L. T. Rhodes Feed and Supply Store. It stands today as the Volunteer Firemen Hall, bearing a Baldwin County Historic Plaque.

DRUGSTORES. The above early photograph of the building that later became Lambert's Drug Store was made in 1906 and is one of the earliest of downtown businesses. The store was directly in front of the entrance to the courthouse at the corner of Hand Avenue and Highway 31. It is seen in the photographs from the courthouse cupola as a barbershop and bathhouse. No memories of Bay Minette are complete without the stories of visiting the soda fountain at one of the drugstores. Stacy's, Humphries, and Baldwin were other drugstores.

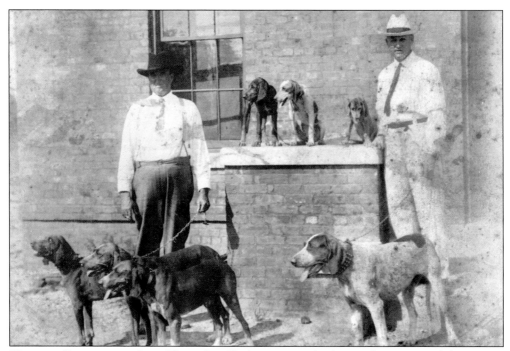

HUNTING DOGS AT THE JAIL. These sheriff's deputies are displaying the prowess of their trusty bloodhounds, used in hunting criminals. The photograph shows the detail of the jail, built in 1910 and used until 1985. Most likely these dogs were used for hunting game as well as criminals.

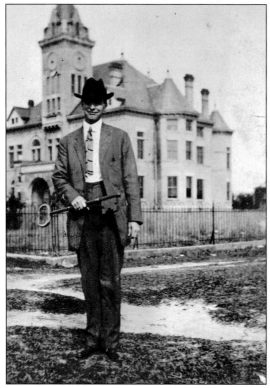

BAY MINETTE MAYOR. The city of Bay Minette incorporated in 1907, electing J. D. Hand as the first mayor. He served only one year, and W. D. Stapleton (pictured here) was mayor from 1909 until 1920. He was also the president of the Baldwin County Bank, which was the county depository. The community of Stapleton south of Bay Minette was named for this businessman and developer.

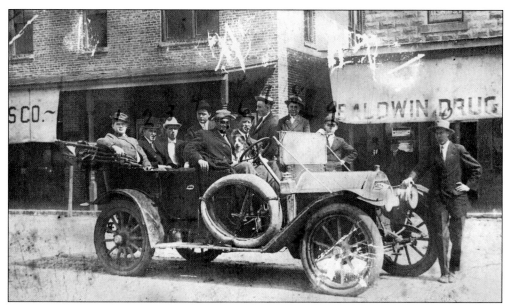

ARCADE ESCAPADES. Stories of a daring ride through the Arcade are told on every porch when families in Bay Minette recall their teenage years and escapades. Horses, buggies, wagons, automobiles, and motorcycles were not allowed to go through the archway, which was part of the Baldwin County Bank on the southeast corner of the square by 1915. However, it is difficult to find someone who remembers the arcade who did not make a famous midnight ride under its archway. One of the stories tells of respected citizens who loaded as many passengers as the Hupmobile would hold and made the run through the arcade as late as 1939, risking a $5 fine.

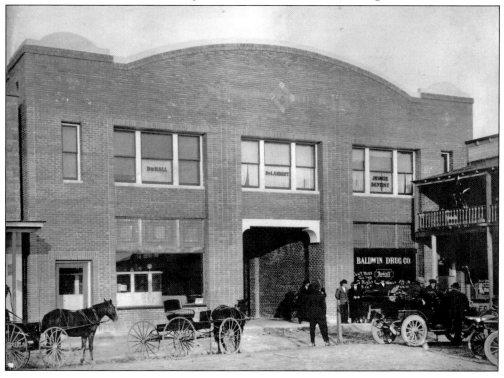

GOVERNOR'S RACE WAGER. Bay Minette was a center of politics, but the residents seemed to be able to mix fun with politics, as shown in this photograph. Dan Blackburn relates the story of his father, the boy in the suit above the drummer, watching the payoff of a political bet. Probate judge Charles Hall and Frank S. Stone made a wager on the outcome of the 1914 governor election, the winner having to push the loser around the courthouse in a wheelbarrow. When Gov. Charles Henderson won the election, Stone was treated to the ride to the tune of Joseph Blackburn beating the drum.

Three

THE PEOPLE WHO CAME TO CENTRAL BALDWIN

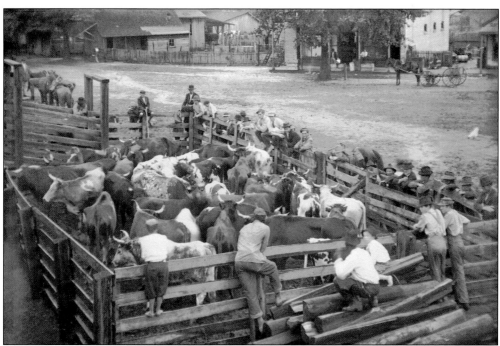

CATTLE PENNED FOR SHIPPING NORTH. The central part of Baldwin County was proclaimed as the "richest farmland ever seen" by the land companies that began to promote the area. The central Baldwin settlements of Stapleton, Loxley, Robertsdale, and Summerdale were built on the spur line—the Pine Knot Special Line. Home seekers moved to small communities nearby as well, settling in Rosinton, Elsanor, Silverhill, and Sonora.

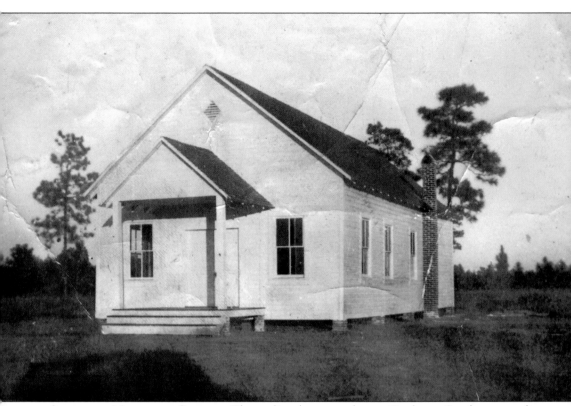

STAPLETON METHODIST CHURCH. The earliest homesteaders to Canby, as Stapleton was first named, were families from Bromley: the Sibleys, Wards, and Trawicks in 1891. The first post office, in the Ward home, was established in 1895. Then the Hamm brothers of Chicago convinced the railroad to build the spur line from Bay Minette to Foley. Completed in 1905 and running several freight trains and two passenger trains per day, the train opened up new land for development, bringing a large number of immigrants. Stapleton boomed with many businesses and a school, and at first, the Primitive Baptist Church served four denominations. Rev. Alphus Davis Duck from Brady was a circuit-riding preacher who came to Stapleton once a month and developed a real bond with the people there. When the Brady church building was no longer used, he persuaded Brady to allow Stapleton to move the building for use as a Methodist church. The story of the church being moved on logs pulled by mules is still recollected by residents.

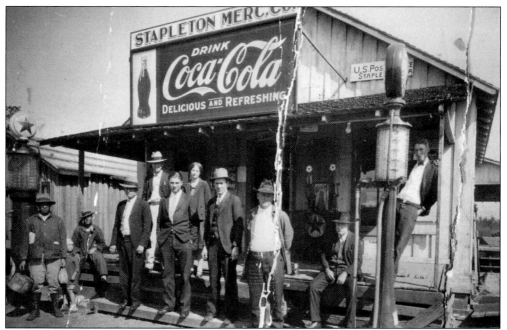

STAPLETON MERCANTILE. This 1920 photograph pictures, from left to right, Charlie Dean, his daughter Maybelle Dean, Leander Sims, Agnew Thompson, Perry Mahathy (postmaster and store owner), an unidentified man, Lillie Durden Mahathy, William Robert Jerkins, Joseph Byrd, ? Reynolds, and Robert Byrd. The store was located on Baldwin Avenue about one half block from the rail line. A gasoline pump is on the right, and kerosene dispenser is on the porch. (Courtesy of Royce Jerkins.)

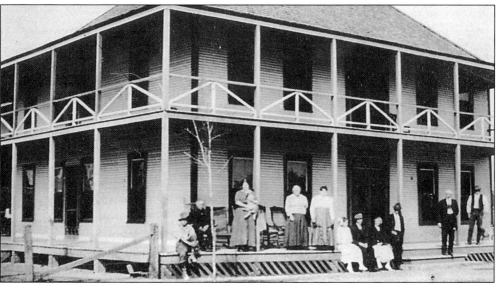

LOXLEY HOTEL. The next stop south on the line was at Loxley, where many hopeful landowners disembarked and stayed the night at the Loxley Hotel. This magnificent structure was built before the rail spur was built and is still standing today. Loxley was a stop on the stagecoach line, the Wired Road, so called because of the telegraph wires along the road from Pensacola to Blakeley. (Courtesy of Loxley City Hall.)

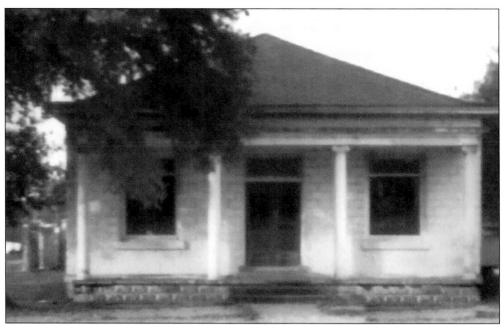

BANK OF LOXLEY, 1910. John Loxley came from Michigan to the community of Bennet to start a lumber camp. Many crew members stayed, and the name of the town became Loxley. The oldest concrete building in Loxley, today the police station, was first a bank, built of concrete stones manufactured by Dean Comstock, who ran a prospering business there. It later became the city hall (seen below with a graduating class of girls from the Loxley School). Loxley was a prosperous town, shipping the abundant satsumas until the freeze of 1929 ruined that business. The first post office was in the depot, with Octavia Sauer as the first postmistress, and in 1920, the Old Spanish Trail was routed through town, bringing road trippers who often stayed overnight. (Above courtesy of the Loxley Police Department; below courtesy of Loxley City Library.)

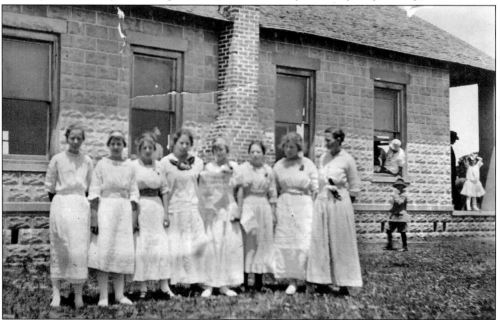

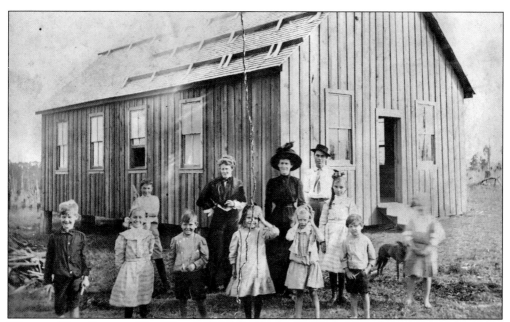

WETZELL HILL SCHOOL. The Wetzell Hill School just north of the Loxley depot was of unique design. Notice the vents in the roof for air circulation. Pictured are Mr. and Mrs. Wetzell (wearing hats) with the schoolmarm employed by the family. In 1918, family member Lillie Wetzell became superintendent of Baldwin Schools, the first female superintendent of a school district in Alabama according to state records. (Courtesy of Loxley City Library.)

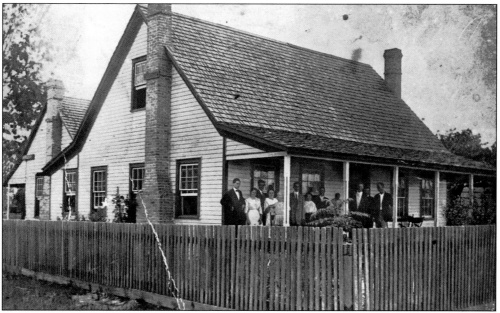

ROSINTON HOME. A farming community east of Loxley named Rosinton was primarily settled by German families. The area produced dairy products, tomatoes, and other vegetables and was quite prosperous, as indicated by this photograph of a home built in the early 1900s. There were as many as 300 residents in the community, which was a stagecoach stop on the Wired Road running between Pensacola and Blakeley.

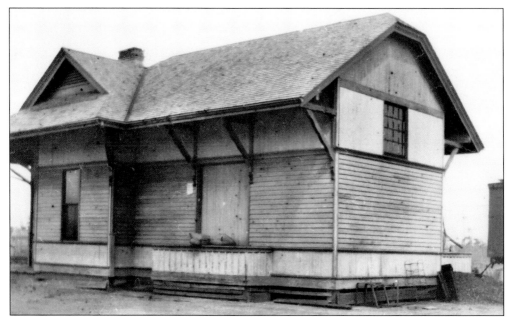

ROBERTSDALE DEPOT. The depot located in Robertsdale was first named the Silverhill Depot and was called that for many years. Robertsdale, however, was so named in 1905, and the people who moved west of Robertsdale established a community named Silverhill. Robertsdale has dubbed itself the Hub City, as its location in the heart of the county enhances activities such as the county fair and cattle auction. (Courtesy of Debbie Owen.)

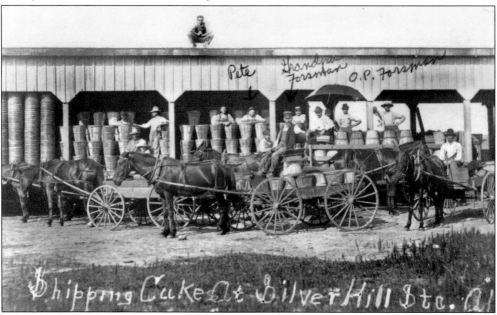

CUCUMBER SHIPPING SHED. Historically Robertsdale has been a shipping point for the many farming communities in the central part of the county, many of these being "forties" or "eighties," family truck farms. It was founded in 1905 by the Southern Plantation Development Corporation of Chicago. In 1921, the town, named for an official of the development company, Dr. B. F. Roberts, was populated enough to be incorporated. (Courtesy of Debbie Owen.)

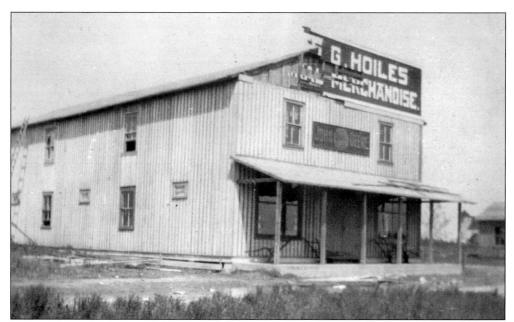

HOILES STORE, ROBERTSDALE. Robertsdale was a trading point for farmers from Silverhill and Elsanor bringing their produce to the sheds for processing and shipping. With the profit from their sales, they headed to the town merchants for supplies to last a year on their farms. Hoiles Store was one of the most prominent general stores in town, carrying virtually all supplies needed to live in the South. The Hoiles were among the first families to settle in Robertsdale, along with the Wilterses, Poos, Lowes, Wynns, and Mulacks. Most of these were from northern states, some with Polish ethnic backgrounds.

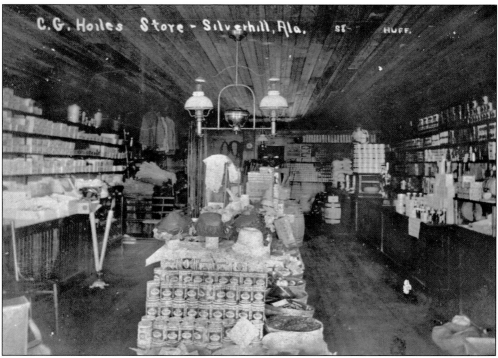

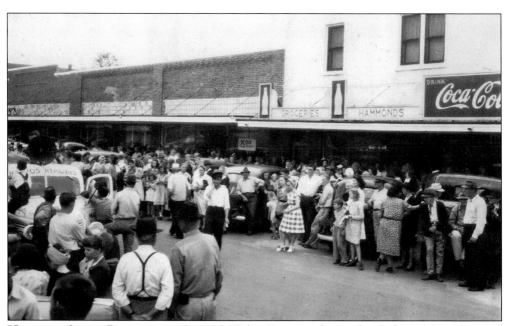

HAMMOND STORE, ROBERTSDALE. In 1905, Walter Hammond moved to Robertsdale and started a mercantile store on the main street. When the first building burned, he rebuilt using brick, and this structure still stands. People outside the store on a Saturday morning are awaiting the weekly drawing for a winner of $100. Walter Hammond became the first mayor of Robertsdale and was succeeded by his sons in the business. (Courtesy of the Hammond family.)

THIS CERTIFICATE IS WORTH ITS FACE VALUE

Board of Education of Baldwin County, Alabama

SERIES **SERIES A** (EDUCATIONAL FUND) Date_____ Number_____

This is to certify that the Board of Education of Baldwin County, Alabama, is indebted to

in the amount of _____ DOLLARS for services rendered as an employee of the Board of Education of Baldwin County, Alabama, as evidenced by the duly exe-

cuted scholastic calendar pay roll for the _____ month ending _____ day of

_____ 193___.

This certificate will be redeemed by the treasurer of the school funds of Baldwin County, Alabama, and payable to the employee or holder thereof, when and at such time as notice shall be given by publication in a Baldwin County Newspaper, or otherwise.

This certificate is negotiable and holder will be deemed to be the owner thereof and of the indebtedness herein certified.

BOARD OF EDUCATION,
BALDWIN COUNTY

For value received I hereby transfer and assign to

By _____ Pres

Attest:

All my right, title and interest in the within certificate _____ Sec'y

_____ _____ Treas.

BALDWIN COUNTY SCHOOL SYSTEM SCRIP. During the Depression, the school system had to issue promissory notes to teachers for pay. Most merchants would redeem the notes at partial value. However, Walter "Pop" Hammond honored the scrip at its full value, earning the loyalty of the education community in the county. (Courtesy of Baldwin County Archives.)

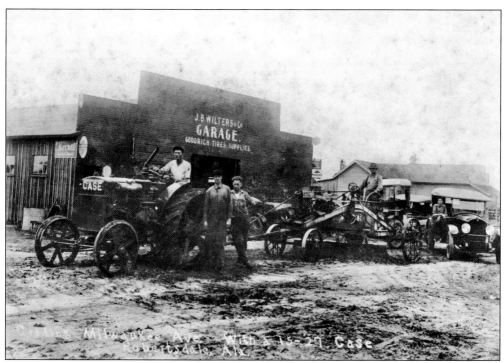

WILTERS' AND COMPANY GARAGE, ROBERTSDALE. The prosperous Robertsdale area farmers were among the first in the nation to use motorized farm equipment, thus the growth of sales and maintenance businesses, as demonstrated in the top photograph: "J. B. Wilters and Co. Garage; Goodyear Tires and Supplies. Grading Wilwaukee Avenue with a 15-27 Case." The Wilters Service Station grew to service automobiles and has become a focal point for Robertsdale citizens throughout the years. It was advertised as a "drive up and get filled station for gasoline and oil."

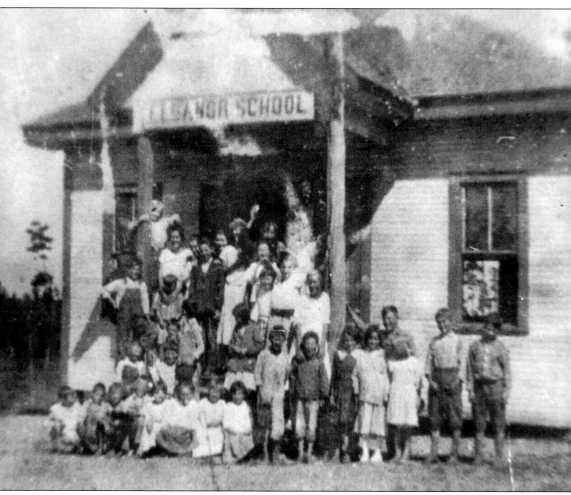

ELSANOR SCHOOL. Elsanor was named for Elsa Norton, the wife of the Chicago dentist who was benefactor for the school with the condition the school be named for his wife. This original school at Red Hill was moved using logs and a capstan to its current site and was used as the school for several years. It was later the "teacherage" and today bears a Baldwin County Historic Marker. Other landmark buildings in town were the U.S. Garage and Elsanor's General Store, owned by Lon Cooper. A brick school was built in 1924–1925 with the first electric power service in the county, donated by Kohler Company of Kohler, Wisconsin. A colony of Mennonites from Arizona settled nearby in 1917. The group, called "Hooker Mennonites" as they used hooks and eyes rather than buttons or zippers, quietly left Baldwin County because of compulsory school attendance, many relocating just over the Florida state line in Escambia County, where their descendants reside today.

SVEA LAND OFFICE, SILVERHILL. East of Robertsdale, the Svea Land Company office, the second building in Silverhill, was built by Oscar Johnson in 1898 using the style of his native Sweden. It was partitioned from its earliest days and used as a school room for the children of the community until the population exceeded its walls and a new school was built. Today it is the Silverhill Library. (Courtesy of Debbie Owen.)

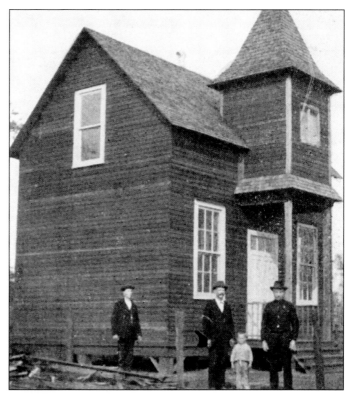

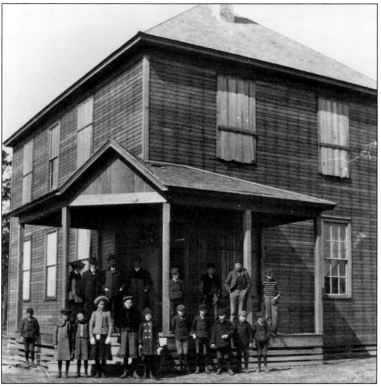

SILVERHILL SCHOOL, 1905. The new two-story building was built with donated labor, with the Svea Land Company giving the money for building materials, $552. It was used as a school from 1905 to 1928. It is today lovingly restored as a private residence. (Courtesy of Debbie Owen.)

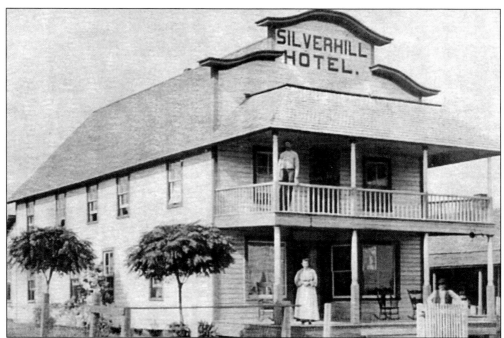

SILVERHILL HOTELS. The Silverhill Hotel, shown in the top photograph, was really located in what is today Robertsdale, across the street from the Silverhill Train Depot on the corner of Ohio and Chicago Streets in Robertsdale. The Norden Hotel in the 1911 photograph below was built in 1905 by A. A. Norden, who had moved to Silverhill from Omaha, Nebraska. The hotel became a favorite of Swedish people from the northern states, and soon an addition was built to accommodate the winter visitors. Records show teachers at the school boarded here during the school year. The hotel was completely destroyed by fire in 1942. (Both courtesy of Debbie Owen.)

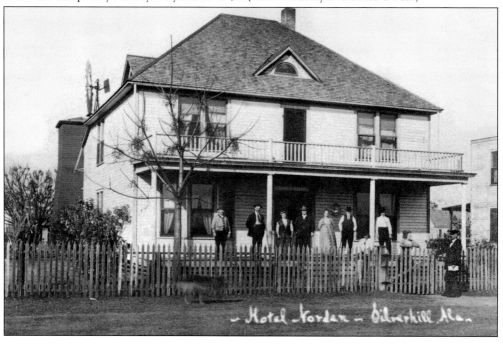

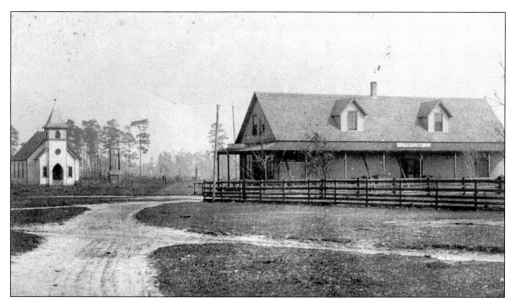

People's Supply Company. The People's Supply Building had become a landmark early in the 20th century. The general store was built in 1902, serving a wide area of farms. Theodore Johnson built the store as an entrepreneurial venture and became very successful. The Mission Covenant Church shown in the background was completed in 1903–1904, with the fence added in 1905. (Courtesy of Debbie Owen.)

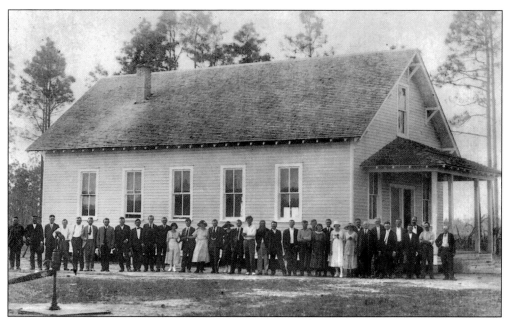

Little Bohemian Hall. Thirteen Bohemian families settled as a group in 1909 just southwest of Silverhill, building the Little Bohemian Hall in 1920 as a community center and school. The building was moved to Silverhill in 1985 to accommodate the increased population and kindergarten classes, and today it is used as a community center in Silverhill. The structure is a beautifully preserved representative of the Bohemian immigrant architecture. (Courtesy of Debbie Owen.)

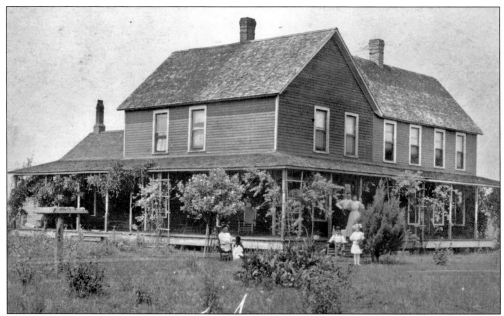

SUMMERS HOTEL, SUMMERDALE. Land south of Robertsdale was sold by the Southern Development Company in 40- and 80-acre plots to Mennonite, Polish, and Lithuanian settlers. The Summers Hotel was in a bustling center of trade and manufacturing for more than 1,000 people. Here the railroad met the primary east-west road of the county, Dixie Road, and was the location of tobacco warehouses, a canning company, and many shipping sheds.

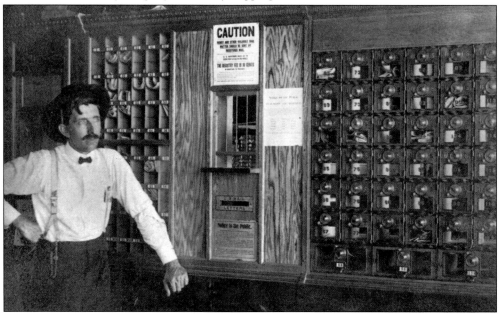

SUMMERDALE POST OFFICE. The Summerdale Post Office was a busy place year-round. The name Sonora was considered for the town, but it was named Summerville for a real estate agent named Summers who ran the Summers Hotel (above). The name was changed to Summerdale upon finding that there is another Alabama city named Summerville and a community located just west of Summerdale had claimed the name of Sonora.

Four

THE PEOPLE WHO CAME TO SOUTH BALDWIN

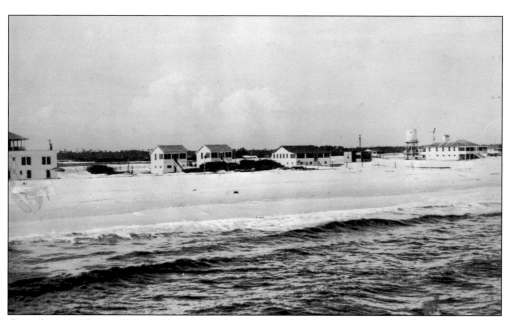

GULF SHORES' SUGAR WHITE BEACHES. The south end of the county reaches from Summerdale to Gulf Shores, east to Florida, and west to Fish River. The boom that occurred after Hurricane Frederic in 1979 has more than tripled the population, mostly due to the resort industry. The early years, however, tell the story of people who came to make a living from the land and the sea.

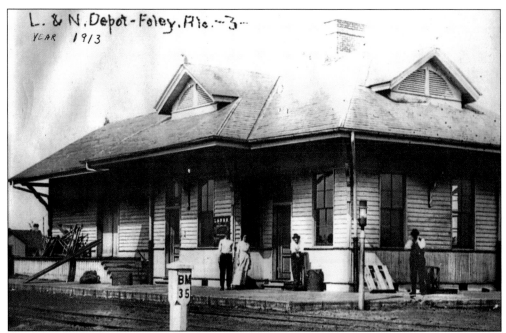

FOLEY DEPOT. The depot was the shipping point for agricultural products from Elberta, Magnolia Springs, Yupon, and all other points nearby. The Citrus Growers Association was a farmer organization that had its own shipping shed and packing plant, equipped with the most modern equipment for "assorting and packing the famous Satsuma orange." The boxcars, used to ship the fruits and the flowers, mainly gladioli, at first had wooden sides and were cooled by ice compartments. Therefore, the ice house in Foley was a major business. After the line was discontinued, the depot was saved by John Snook and was later restored as the city museum, housing train memorabilia and model train displays. (Both courtesy of Foley Museum.)

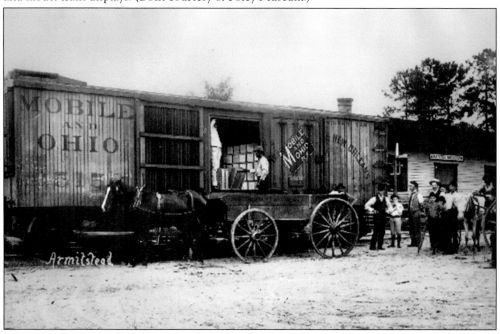

THE FOLEY LIMITED. Foley treasures its heritage as the end of the line on the "Pine Knot Special"—so nicknamed when the train began burning pine instead of coal. After the hurricane of 1916, there was so much pine debris lying near the tracks that the company converted the smokestacks, and often at stops passengers would help gather pine knots for fuel. Homeseeker excursions were run the first and third Wednesday of each month, sponsored by the railroad and the land development companies. There was a passenger train twice a day going to the county seat, and students rode the train to Bay Minette for their final two years of high school for some specialized curriculum. The Foley Depot was the disembarkation point for the well-known Magnolia Springs resort and beautiful Perdido Bay, which boasted fishing and bathing facilities.

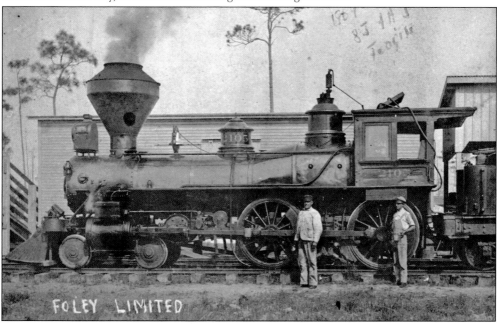

FOLEY LIMITED

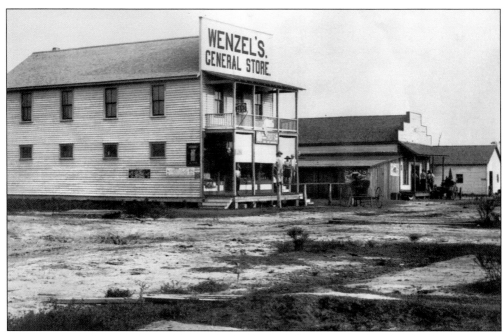

WENZEL'S STORE. Foley was founded in 1901 by J. B. Foley, who promoted the town avidly. A 1922 publication proclaims the advantages of Foley as the "Zenith of Baldwin, with 'Pep' as her first name." Wenzel's Store here was on Chicago Avenue. At one time, a dance hall was in the rooms on the second floor, and at other times, it was used for Presbyterian church services.

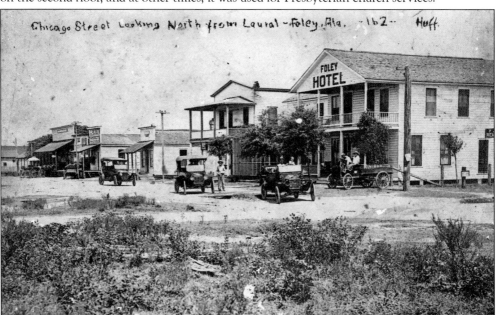

FOLEY HOTEL. An advertisement by Cooney Real Estate advertised the following: "Homeseekers Cordially Invited to Visit Foley, Alabama, The Home of the Satsuma Orange and Pecan. I offer at Foley: Choice Farm Lands, Improved Farms, Orange Groves, Pecan Groves, Winter Homes and Town Lots. Can show many charming homes. Many successful farmers, those who have made good." Developers sponsored excursions with a night at a hotel for prospective homeowners.

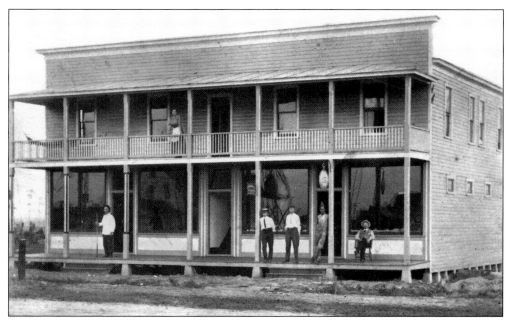

DRUGSTORE. Laurel Street was the first business district and the Dumas Drug Store shown here about 1910 one of the earliest businesses. Also on the street were Stelk's Hardware and A. Hooks Store. The man on the left in the photograph is holding a pool cue, and the woman on the upstairs veranda lives in housing quarters above the stores below. The early caption reads, "Drug Store and Barber Shop."

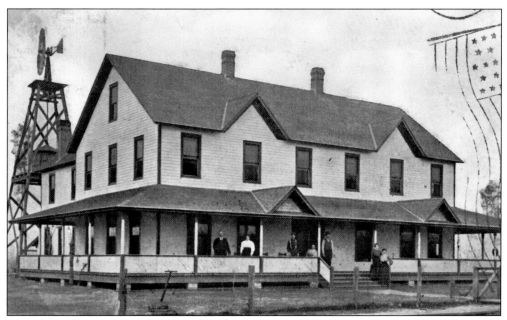

MAGNOLIA HOTEL. Foley's Magnolia Hotel was built in 1908, by the Magnolia Land Company, J. B. Foley, and Associates. John Lear was the first manager of the hotel and brought fame to the hotel for Southern hospitality and home cooking. The John Snook family purchased the hotel as a residence, and today the hotel has been restored and is open for guests.

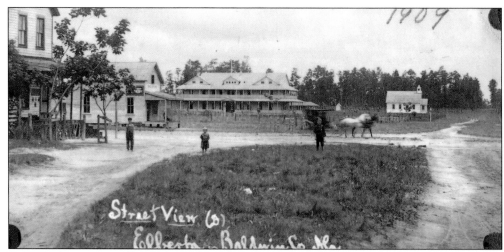

FOR THE GOOD LIFE. Elberta, founded in 1905 by the Baldwin County Colonization Company, was primarily settled by families of German origins. The town was named by one of the earliest settlers, who was partial to Elberta peaches. The motto of the town is "fur das gute Leben" (for the good life). German heritage is celebrated each fall at the German Sausage Festival. (Courtesy of Baldwin County Heritage Museum.)

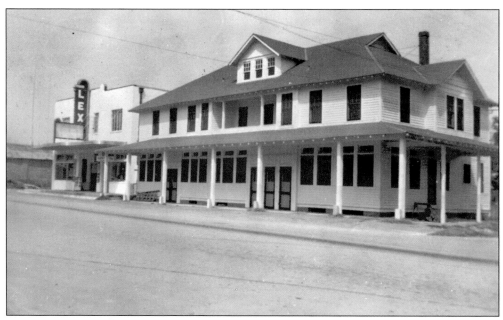

LEX THEATER. As Elberta prospered, a packing plant and shipping platform were built to handle the large volume of produce. The town soon had a Lutheran church, a Catholic church and school, and several downtown businesses. The post office–general store was among the first buildings constructed, with Herman Schroeder as the first postmaster in 1907. The Lex Theater and Elberta Hotel photographed here were owned by J. A. Pilgrim.

MEXIWANA HOTEL, JOSEPHINE BEACH. The Southern State Land Company mapped Josephine in 1898 for the McPherson family, who had purchased the land from Raphael Semmes. Semmes's home was there in the 1840s. The McPhersons built the Mexiwana Hotel and had a 52-foot freighter, also named the *Mexiwana*, delivering mail, goods, and passengers to the resort communities. Another hotel was Moss Oaks, owned by Amos Moss, the first postmaster of Josephine, who named the town after his daughter. When Lee Ballard moved to Josephine, he joined the family of his wife, Margaret Mae Climie, in the Climie Enterprises, operating a sawmill, boat works, and a carpentry shop. They built at least 17 houses in Josephine. These families were known for riding out hurricanes in their homes, even the terrible waves of 1916. (Above courtesy of Lillian Ballard.)

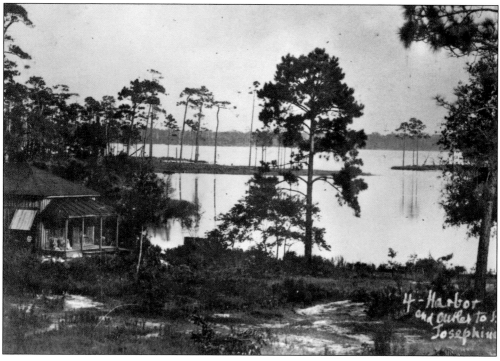

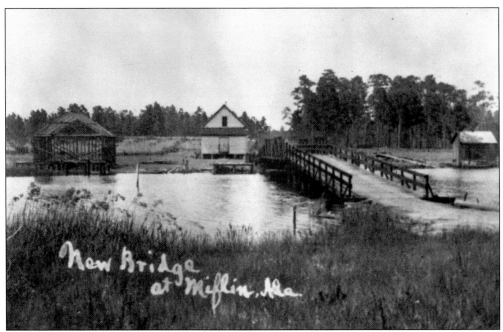

BRIDGE AT MIFLIN. The settlement of Miflin was named for the family who owned land in the area in 1840 on the north shore of Wolf Bay. The 1909 bridge across Miflin Creek replaced a ferry that was pulled by hand. This bridge features a turntable opening for pleasure boats and sloops making excursions up the creek.

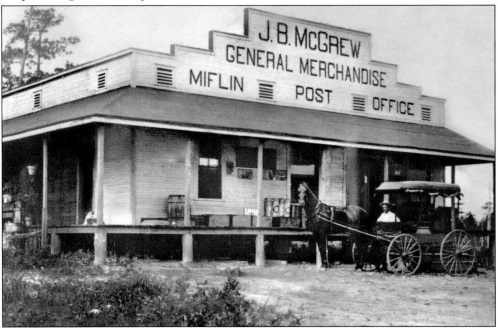

MIFLIN POST OFFICE. The post office was located just to the left of the old bridge. It was also a general store and was owned and operated by J. T. Johnson and J. B. McGrew for about six years. The *Minnie J* was the Johnsons' pleasure boat, known for taking visitors out into the Gulf and the family to the Swift Presbyterian Church on Sundays.

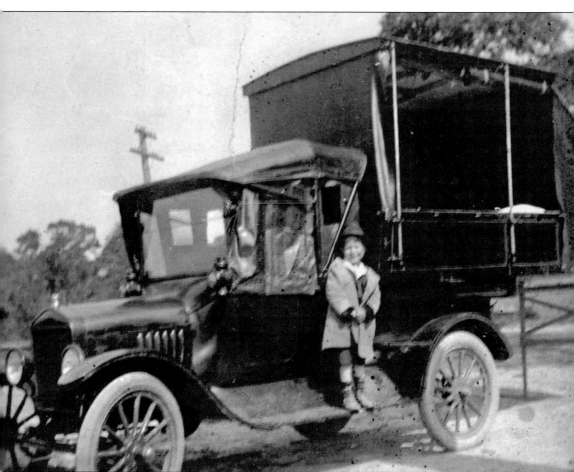

PERDIDO BEACH RECREATIONAL VEHICLE. Perdido Beach was famous as a resort area for many families from upstate Alabama. A group of families from Montgomery came and spent summers here, routing through Pensacola and catching a supply boat, the *Mexiwana*, to reach their destination. Permanent residents included the Randolphs, who operated an ice plant, store, post office, and fish market. A Chicago native by the name of Froelick built resort cabins, and a group of families built a clubhouse, the Beauvoir, on the banks of the bay. Alex Resmondo was in the lumber business, and Rufus Kee and Frank Parker were boat builders. The Suarez brothers were builders who constructed the Perdido Beach hotel. Outdoor life was rapidly becoming entertainment rather than a way of life for survival. This wonderful camper built on the back of a pickup truck was photographed at Perdido Beach. The family hiked, swam in the Perdido Bay waters, cooked over an open fire, and told stories—the same stories told today.

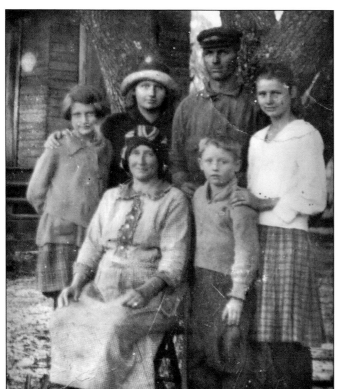

CALLAWAY FAMILY. Orange Beach is a settlement on the eastern part of the Pleasure Island peninsula, named for the fruit grown in the area and used as an advertisement for attracting new residents. The earliest founders were the Callaways. James Spruell Callaway and his wife, Eliza Rose, had eight children, one of whom was Capt. James Spruell Callaway, a beloved ship captain and man of all trades. (Courtesy of Gail Graham.)

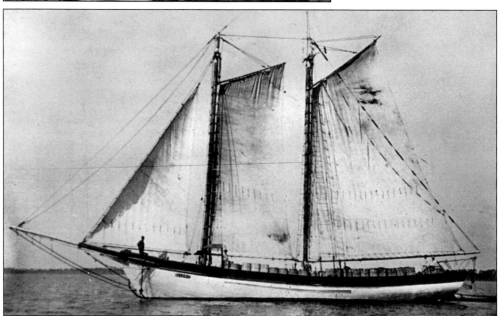

ELLEN C. This Callaway family sailing packet was built by Capt. Jim Callaway, named for his wife, and used for at least 50 years. The boat had to be anchored far from shore, as the shoreline was too shallow to dock boats. The fishing industry supported the Callaways, who have wonderful family stories of a life in the times when everything needed for survival was made and produced at home. (Courtesy of Orange Beach Museum.)

ORANGE BEACH POST OFFICE. The Orange Beach Post Office was established officially in 1910 and was located on the beachfront row of businesses. The owners of the post office lived upstairs in the building. Until the mid-20th century, most people lived on the north side of the peninsula in Orange Beach. Very few lived on the Gulf side, but rather on Wolf Bay or Terry Cove, as there was no pass or canal. (Courtesy of Orange Beach Museum.)

ORANGE BEACH MAIL BOAT. The mail boat was the primary connection with other towns until October 1923, when Brown Hudson, Jim Hudson, and George Burkart turnplanked the road between Orange Beach and Caswell. One of the most fondly remembered mail boat captains was Rufus Walker Sr., who picked up mail in Lillian, Miflin, Bon Secour, Mobile, Pensacola, and Gulf Shores. (Courtesy of Gail Graham.)

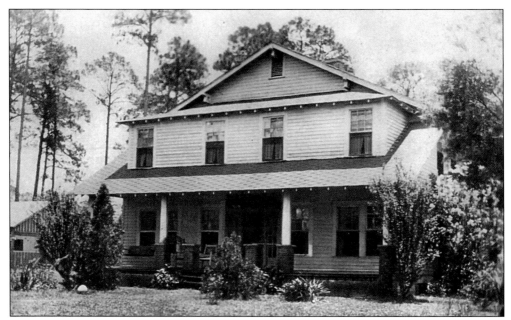

ORANGE BEACH HOTEL. There were probably only 40 to 50 full-time residents in 1900, not counting all the Callaways and the Walkers, the main families in the area, but the vacationers brought summertime prosperity to Orange Beach. The hotel was built by Hilda and Edward Dietz around 1920, even though there were other resort facilities prior to that date. (Courtesy of Orange Beach Museum.)

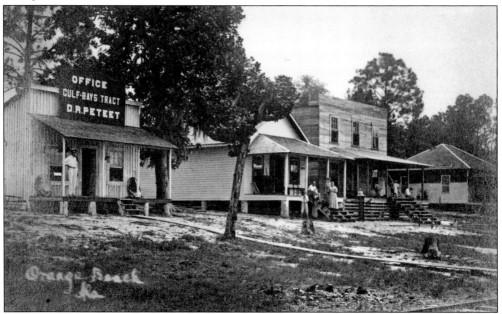

BEACHFRONT BUSINESSES. These businesses operated without electricity until well into the 20th century. Alma Dietz Walker and her husband, Rabun Earl Walker, did not even get electricity until 1956. Tourists still arrived primarily by boat and perhaps by Model Ts or horse and buggies traveling the extremely rustic road down the peninsula to Orange Beach. (Courtesy of Orange Beach Museum.)

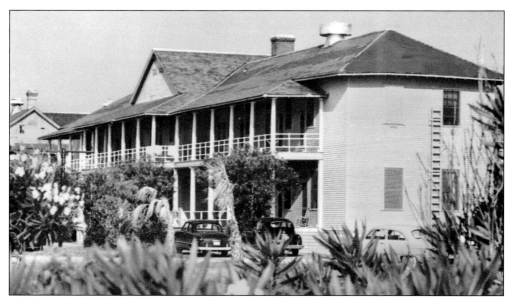

FORT MORGAN. A fortified post was erected on Mobile Point in 1833 and named for Daniel Morgan, an American general during the American Revolution. It replaced a wooden fortress named Fort Bowyer, built in 1813 and destroyed by a hurricane in 1819. The fort guarded the entrance to Mobile Bay through World War II with her sister installation, Fort Gaines, located across the channel on Dauphin Island. The *Tecumseh*, an ironclad monitor sunk by torpedoes during the Battle of Mobile Bay in 1864, remains off the coastline of Fort Morgan. A community grew up around the fort with the inn pictured above for guests and a post chapel, which was used as a school during World War I. A post office for the community was established in 1892.

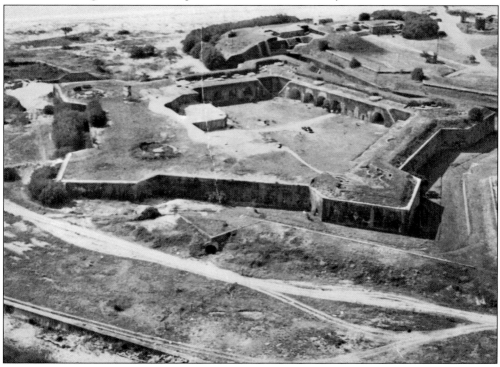

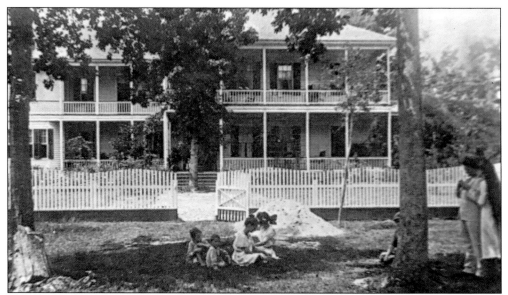

SWIFT-COLES HOME. The French heritage in Bon Secour is the earliest European influence in the county. In 1702, the LeMoyne brothers had built a resort, the "chapel of ease," or Bon Secour. Jaques Cook, a Frenchman from Montreal, was given a land grant by the king of Spain, and seven generations of the Cook family have lived in Bon Secour. The Swift family established a lumber business on Schoolhouse Creek and built this remarkable home in 1882. It was originally a four-room house, but Charles Swift added a room with the birth of each of his 11 children. The house is now a county historic site. Bon Secour is also the home of the Weeks family of Creole descent, for whom Weeks Bay is named. The area is known nationally for the seafood processed in Bon Secour Fisheries. (Both courtesy of Baldwin County Archives.)

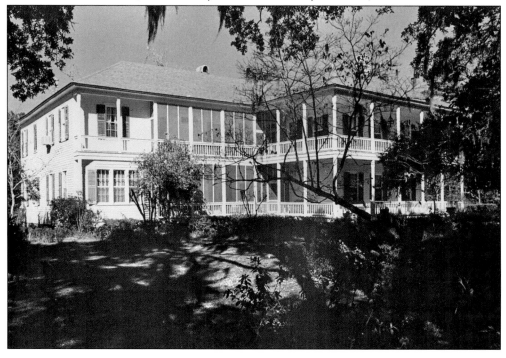

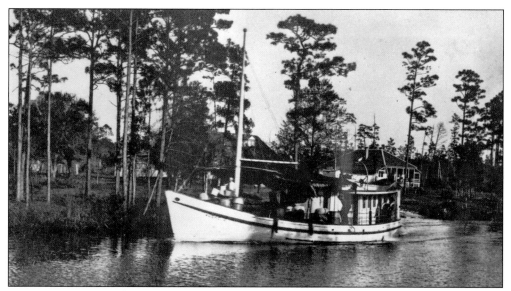

MAGNOLIA SPRINGS. This idyllic town was a shipping and receiving point for Mobile trade, usually delivered by the *Magnolia* supply boat, making stops along the eastern shore of Mobile Bay before coming to the Magnolia Springs stop. The *Foley Onlooker* carried the news that the *Magnolia* had been launched in Mobile in April 1911 to bring fruit and produce of Baldwin County to the city and carry passengers to the Eastern Shore. The stops were at Zundels Wharf, Fish River, Bon Secour, and Magnolia Springs. It was 75 feet long and had a 15-foot beam. The post office below was listed in 1916 with a rural route and still has the only full-time mail water route in the United States.

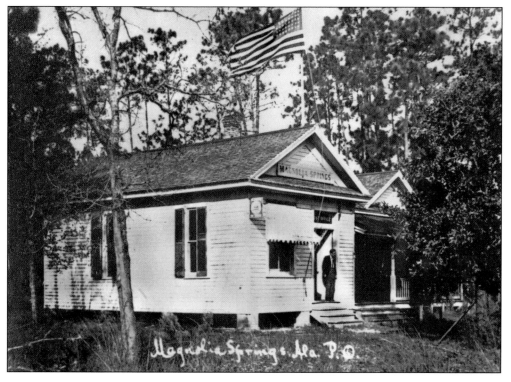

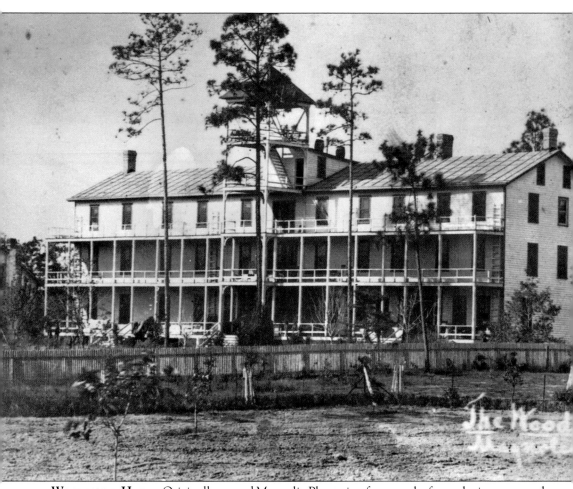

WOODBOUND HOTEL. Originally named Magnolia Plantation for a nearby farm, the incorporated city of Magnolia Springs is located on the beautiful Magnolia River, which early became a resort destination because of the springs there and the easy access to Mobile Bay. There were many hotels, represented by this wonderful Woodbound, built by Englishman John Walker in the 19th century. Guests paid $17.50 a week for room and board in this three-story, 54-room inn. This hotel was situated near one of the famous springs of pure water, which was bottled and shipped to Northern cities. The hotel burned in 1911 after being struck by lightning. The pure spring waters here were known for their clarity, and swimming in the Cool Pond was an excursion for a warm afternoon. The winter guests enjoyed the relatively mild climate, but winters were not warm enough for swimming in the river. Parties and dances were held every weekend, and many pleasant days were spent on the verandas and the five-story overlook.

Five

THE PEOPLE WHO CAME TO THE EASTERN SHORE

JACKSON'S OAK. The Eastern Shore, on the eastern side of Mobile Bay, from its earliest days has been the location of dramatic historic events. Native American shell middens are joined by the ruins of European settlements. The oak pictured above is at the site of the Village, where the Creeks, the Spanish, the French, and Andrew Jackson held meetings before battles.

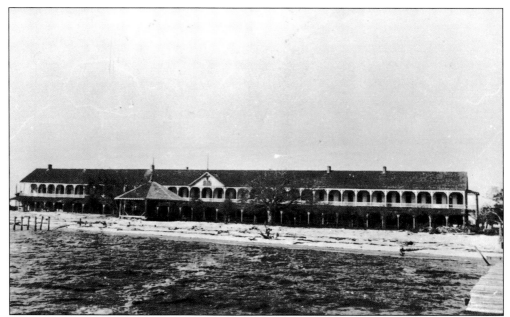

POINT CLEAR GRAND HOTEL. Point Clear has long been a summer resort for escape from heat and diseases of the city. The 1875 Grand Hotel photographed here replaced the original 1847 hotel, which had been a hospital for Confederate soldiers, many of whom are buried in the nearby Confederate Rest. The third and current Grand Hotel was built in 1939 and was used for military training in World War II.

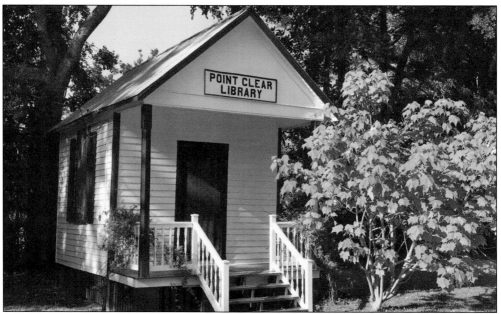

POINT CLEAR LIBRARY. *Ripley's Believe it or Not!* listed this building as the world's smallest library. It was started in 1920 by the Point Clear Book Club, measuring 13 by 14 feet. Residents say that the building served as the school library for many years and was also open to the public on Saturday afternoons. The first librarian, Mrs. Otto Zundel, lived near the library. (Photograph by John Lewis.)

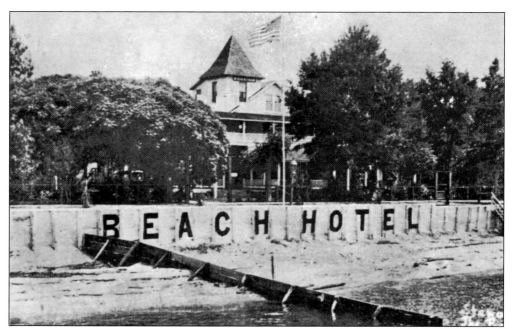

BEACH HOTEL. Just north of the Grand Hotel was the landing at Battles, formerly Battles Wharf, a well-known vacation center. The heyday of the resort was in the Gay Nineties, when visitors came from miles around. A. F. Hutchings built the Beach Hotel, reportedly by remodeling a well-built log house and transforming that into a home-style dining room. The dining in the hotel was known for the Old World touches that Hutchings gave to the meals, as he was from England. After the hotel burned in the 1930s, it was rebuilt and operated by Grace Hutchings, daughter of the original proprietors.

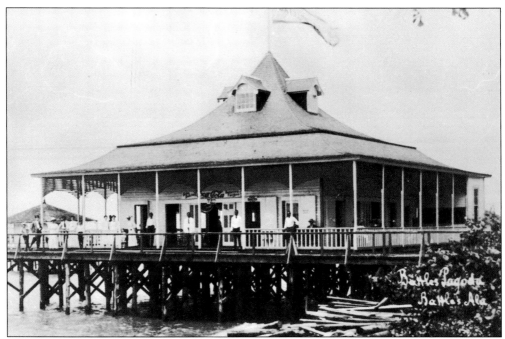

BATTLES HOTEL AND PAGODA. Just up the beachfront from the Beach Hotel was the Battles Hotel, built by Capt. Buck Curan, a bay boat captain who ran moonlight excursions to the resort hotel. The large wharf had a pavilion and bathhouse (above), which was popular among people who enjoyed the "long handled" bathing suits and the novelty of "going in washing" with members of the opposite sex, quite revolutionary at the time. Many private and public parties were held on the pagoda over the bay. Battles was the location of the landing of the boat bringing the first Fairhope Single Tax Colony settlers.

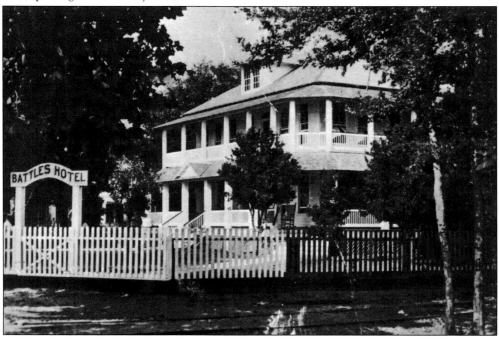

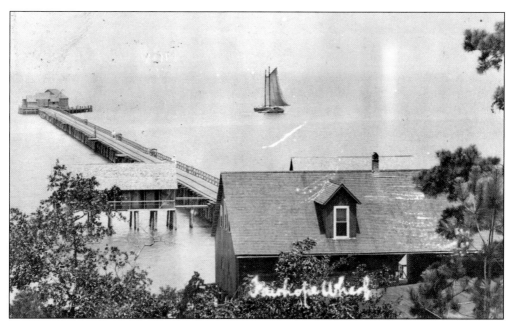

FAIRHOPE SINGLE TAX COLONY. North of Point Clear, a community named Alabama City became home for a group of utopian colonists who established an experiment in economics in 1894. The revolutionary Single Tax Colony made its renowned settlement at what they called Fairhope because one of the founders made the statement that the experiment holds "a fair hope of success." The town prospered on the bluff above this beautiful public beach and pier.

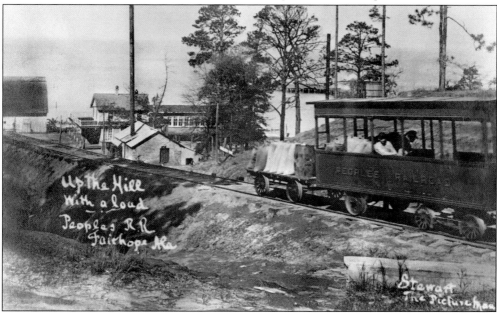

PEOPLE'S RAILROAD. One of the cooperative institutions of the Single Tax Colony was the People's Railroad, begun in 1912. The plan, ardently proposed by E. B. Gaston, was to connect to the Louisville and Nashville line 14 miles east of Fairhope at Robertsdale to increase access to colony land. One mile of the line was completed and served the community for 10 years, bringing goods up Wharf Hill into downtown.

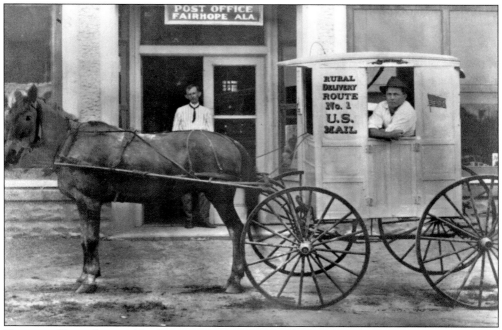

FAIRHOPE POST OFFICE. Fairhope was a community that treasured writing, as evidenced by the heavy correspondence logged with the postal service. Mail was delivered by horse carts after having come from Mobile via the mail packet *Lucille*, which also made stops at Daphne, Montrose, and Battles Wharf. Many addresses were simply the name of the cottage, as described in the book *Fairhope*.

FRIENDS MEETING HOUSE, FAIRHOPE. Religious groups, such as the Quakers in Fairhope, were attracted to Baldwin County. The Friends Meeting House was next to the school built for Quaker children. The meetinghouse is still a vital part of the Fairhope community. Many Quakers from Fairhope moved to establish colonies in Costa Rica after World War II, but several families remained in the area. (Courtesy of Debbie Owen.)

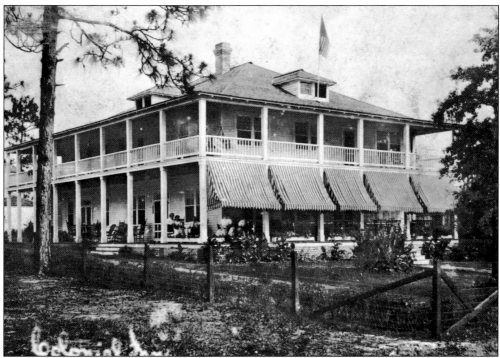

THE COLONIAL INN, FAIRHOPE. Known as Fairhope's most distinctive hotel, the Colonial Inn opened near the beginning of the 20th century and was operated by the Sacriste family for at least 50 years. At the prime position on Mobile Street facing the pier and bay, it was located next to the famous gully, used for outings and entertainment, and auto access to the hotel was by a wooden bridge over the gully. Other hotels in Fairhope included the Volanta Hotel, Rest Cottage, Gables, Tumble Inn, Kanuck, and Murray Hotel. From the beginning, businessmen and tax colony officials promoted the town for recreation and tourism. The layout of Fairhope allotted an unusual amount of land for public use, both bayfront and park areas.

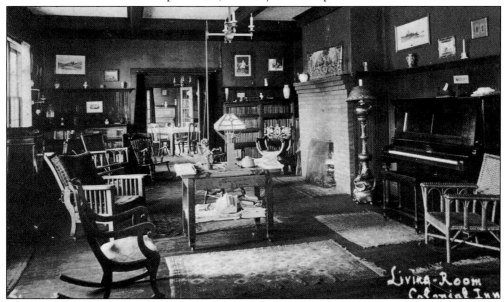

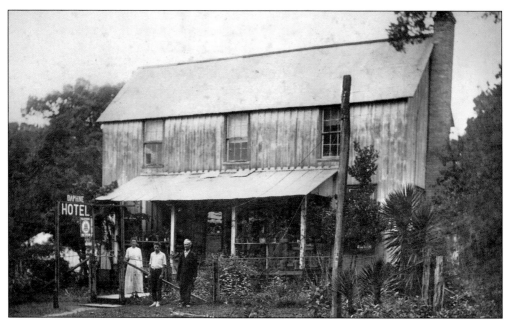

DAPHNE HOTEL. The Daphne Hotel was owned and operated by Mr. and Mrs. Warren C. Davis, pictured here with their son, John. Located on College Avenue, many normal school students boarded there. People coming to Daphne to catch the boats to Mobile could board their wagons and horses here. Notice the telephone pole and the first phone in the town. Today it is a lovely historic residence. (Courtesy of Daphne Museum.)

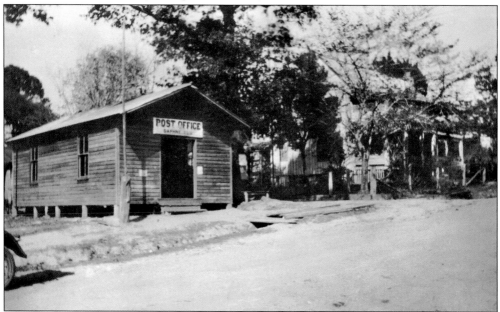

DAPHNE POST OFFICE. Different landings were all along the bayfront, but when the owner of Howard Hotel, William Howard, became postmaster in 1874, he named the town Daphne. Some say the name honors his wife, who planted the mythical laurel trees, but many say the name honors a servant named Daphne who had nursed many families through yellow fever epidemics. (Courtesy of Daphne Museum.)

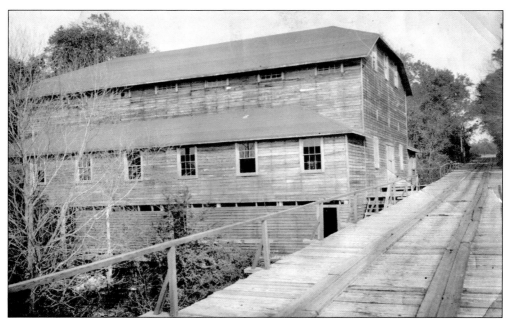

DAPHNE GYM. Wharf Street Dock was one of the busiest on the Eastern Shore. At the base of the pier was the gym, an all-purpose building built by the May Day Association. The gym was used by the nearby normal school for productions and public dances, and basketball games were held there many afternoons and evenings. It provided entertainment for visitors who came to Daphne for the day from Mobile.

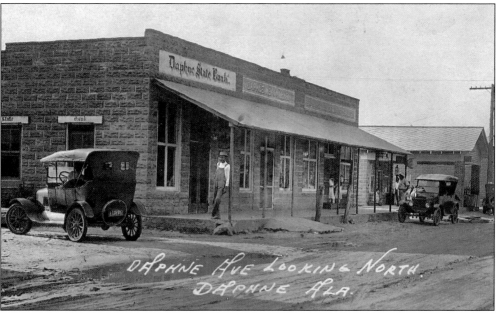

TRIONE'S STORE, DAPHNE. Allesandro Mastro-Valerio bought a tract of land in 1889 and persuaded other Italians—Drago, Allegri, Corte, and Lazarri—to make this their home. The building above has been Daphne State Bank, the post office, and the memorable Trione's store, and today it is a restaurant. Many Italians settled just east in Belforest community, where they had large farming operations. (Courtesy of Daphne Museum.)

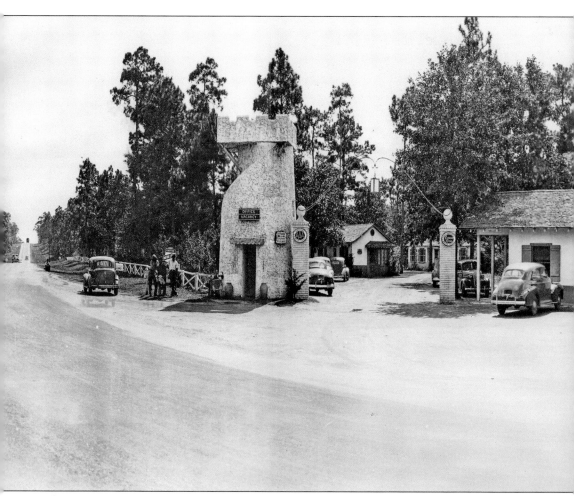

SPANISH FORT TOURIST VILLAGE. Spanish Fort is the gateway to the causeway, connecting Baldwin County to Mobile in 1927 with the completion of the Cochran Bridge across the Mobile River. The site is the location of a fort first built by the Spanish but enhanced and occupied during the War Between the States. The siege of Spanish Fort in April 1865 lasted 13 days before the battle

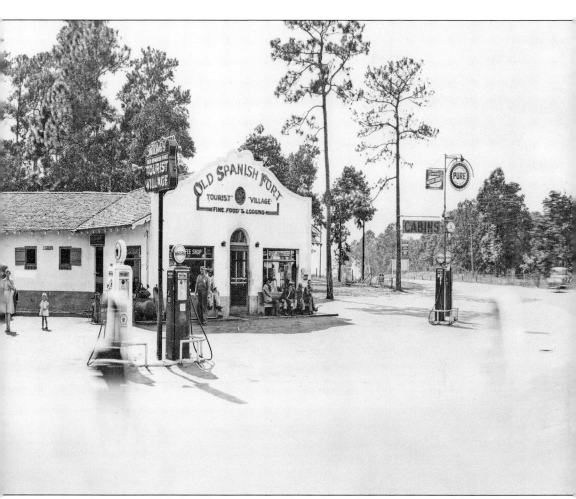

moved up the river to Blakeley. The photograph here shows the tourist court of the 1930s. In 1928, George Fuller moved to the area after visiting the famous Fairhope experiment, leaving his position as assistant editor of the *Chicago Tribune* for a new life in the South. He and his family have developed a vibrant community at the top of the hill. (Courtesy of David Fuller.)

MONTROSE POST OFFICE. The red clay cliffs in Montrose, Ecor Rouge, have always been a landmark for navigation, the highest bluff on the coastline from Texas to Maine. Montrose boasts an 1890 post office built by Capt. Thomas Marshall, the first postmaster. The one-room building served two dozen families who picked up their mail that had been delivered from Mobile by boat. (Photograph by John Lewis.)

LITTLE BETHEL. In 1867, land was deeded to a group of ex-slaves as trustees for the Little Bethel Baptist Church. Russell Dick, a well-known citizen whose mother, Lucy, came into Mobile on the slave ship *Clothilde*, was deacon and sexton here. He is remembered as an industrious and exemplary citizen who owned much Daphne land and ran several businesses. He is buried in this cemetery. (Photograph by John Lewis.)

BLAKELEY SCHOOLHOUSE. Just north of Spanish Fort, the community of Bromley was developed for work in the lumber industry, the main business being the Sibley Mill. The harbor there was a deep one and was a connection point for shipping to Mobile. The Tompkins-Watson family purchased land in Bromley and built a community school on their own land on Magnolia Church Road. Rebecca Burke Tompkins (right) was the daughter of a former slave in Selma, and she and her husband, George, moved to Bromley at the dawn of the 20th century. The Tompkinses were both school system employees for many years, and the building is today the Little Red Schoolhouse Museum, located in Bay Minette and dedicated to the memory of this remarkable family.

JASON MALBIS. One successful colonization account is the Greek settlement near Spanish Fort. Jason Malbis and William Papageorge had the goal of equipping their fellow countrymen for a new life in America through rural work away from the big-city temptations. They began with the purchase of 120 acres and soon had built a plantation in which they could realize their goals. (Courtesy of Malbis Plantation.)

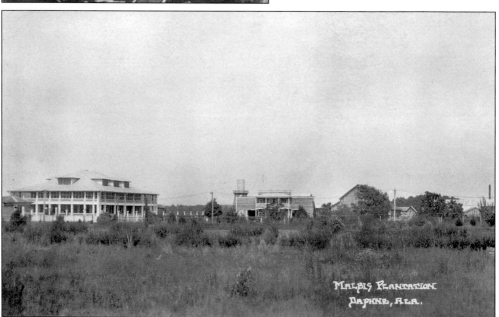

MALBIS PLANTATION. The company provided dormitories for workers and clergy, a canning factory, icehouse, power plant, and all resources for communal needs. They also had a successful commercial bakery in Mobile and owned a loading dock at Stapleton for the shipping of products. The Greek Orthodox church on the property was built of materials from Greece and is dedicated to the memory of Jason Malbis. (Courtesy of Malbis Plantation.)

Six

THE PEOPLE WHO CAME TO FARM

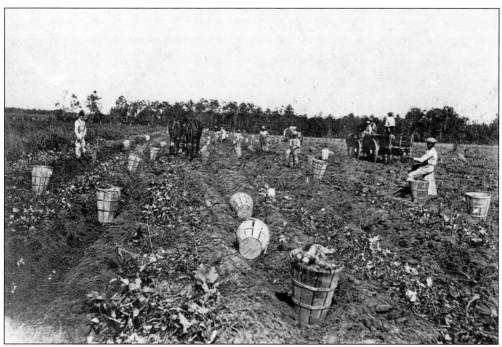

POTATO FARMING. Until the latter part of the 20th century, most per capita income was from agriculture. The growth of the county prior to 1980 was virtually all related to agricultural industry. This rural county was a landscape of pine forests, farms, and pastures. The rich farmland yielded crops for family use and local sales, but most income was related to cash crops such as potatoes, as shown in this photograph.

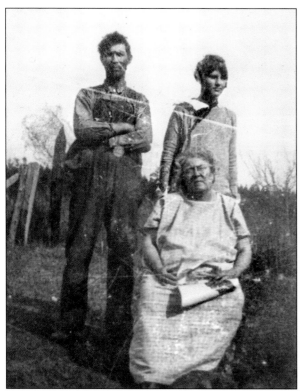

AN IMMIGRANT STORY. The typical farm family had moved to Baldwin County from a Midwestern state, was recently from Europe, or was a first-generation immigrant. The family of William Coon, son of German immigrants, read an advertisement in Pennville, Indiana, corresponded with an agent, then sold everything and moved south. When they arrived in 1920, they got off the train in Bay Minette and were met by the agent, who took them to a boardinghouse for the night. They eventually bought a 40-acre farm south of Bay Minette and struggled to make ends meet for more than 20 years. The typical earliest farmhouse was the dogtrot-style house with a breezeway through the center, but immigrants brought northern architecture with them when they built new homes. Pictured are William Coon, his wife, Leafy, and daughter Harriet in 1924.

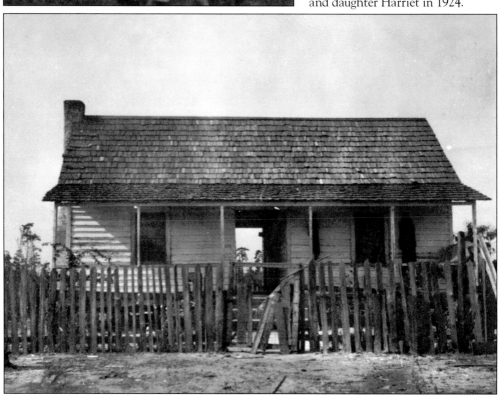

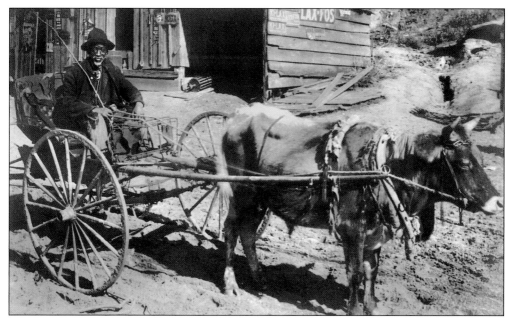

HORSE AND BUGGY. Most early African American residents of Baldwin County came as homeseekers during the early-20th-century land development movement as well. There were very few descendants of slaves already in residence in the area, but the employment and housing opportunities were abundant in the county as farming and industry boomed. This man is posing with his buggy for hire, perhaps running a taxi service.

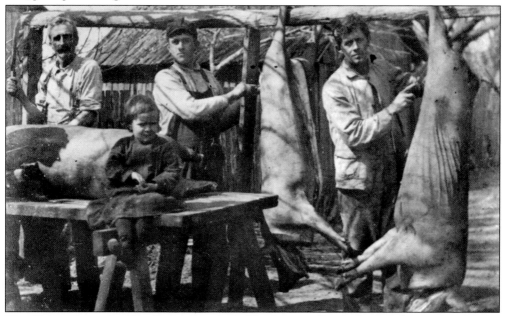

HOG BUTCHERING. A self-sufficient farm had chickens, a milk cow, beef cattle, oxen, and mules or horses and needed to purchase relatively little at merchants. Hogs were a major source of family stores, with the butchering taking place after the first frost of the fall. Every part of the hog was used, whether as lard, meat, or fertilizer. Meat was typically cured in a smokehouse on the farmstead.

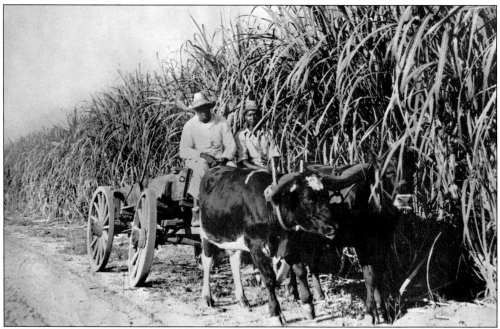

SUGAR CANE SYRUP. Sugar cane was an important crop for local consumption and sales, but there was never a large refinery in the county. Fields such as the one seen here were a common sight, and every child was taught to strip and cut the cane, with a reward of being offered a drink of the cane juice right from the mill. Making cane syrup is almost a lost art, and those who remember the event can well recollect the smell of the cane juice cooking into the rich syrup. The art of knowing just when to "pull" the syrup is critical and is passed from one generation to the next in a few local families. There was a mill such as this one in most communities.

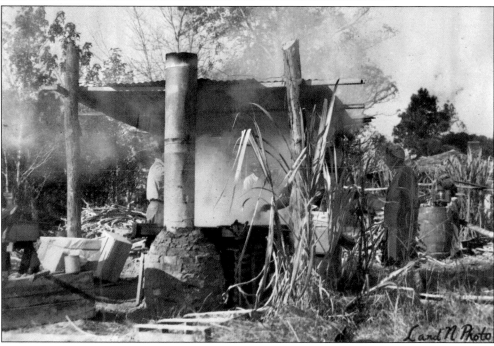

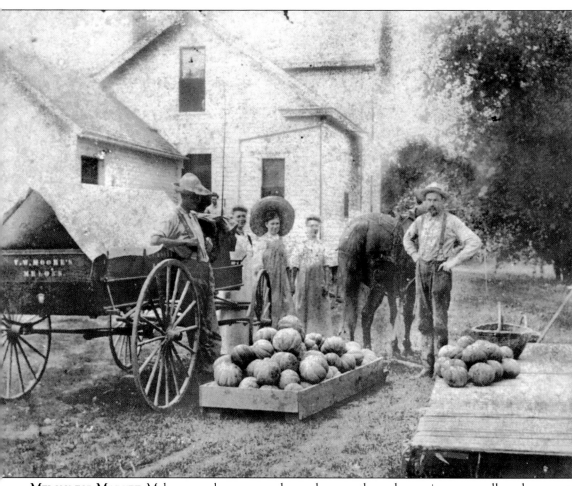

MELONS FOR MARKET. Melons soon became a cash crop because the early growing season allowed the harvesting of watermelons before the Fourth of July for sale nationwide. As melons grow best on land which has been fallowed for several years, the virgin soil yielded excellent crops. Cantaloupes were also grown, as pictured above as the wagon labeled "T. V. Moore's Melons" is loaded. Melons on the dock in Mobile labeled from Baldwin County were the catalyst for Jason Malbis to seek the land of Baldwin for the Greek plantation. Notice the house is not of typical Southern architecture but rather Midwestern in style. Southerners say that Northern homes were built to keep the weather out and Southern homes were built to let the weather in. Homes built in the four-over-four style usually added a shade roof over the bottom floor, creating a porch needed for catching the breezes.

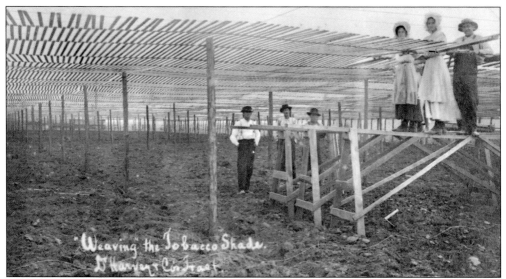

TOBACCO SHED. This photograph is labeled "Weaving the Tobacco Shade. D. Harvey and Co. Tract" The Harvey and Company tobacco company was one of the largest producers of the cash crop. The photographs show that tobacco was best cultivated in a shed to shield the crop from intense rays and to maintain a moisture level needed for a successful yield. Notice the weaving of the roof of the shed using strips of wood. Few farmers cured the leaves on their own farms, as is evidenced in the scarcity of tobacco drying barns in the countryside. Summerdale businessmen developed a system for drying the leaves effectively, producing cigars or storing the tobacco leaves until the price was at an advantage. Workers boarded at the Planters' Inn, a large hotel in Summerdale.

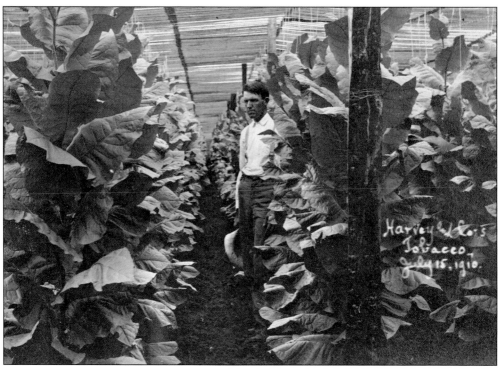

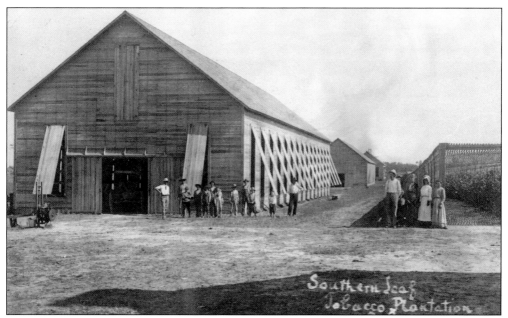

TOBACCO CURING BARN. The photograph is labeled "Southern Leaf Tobacco Plantation, July 8, 1911." Summerdale was the primary site of tobacco curing and warehousing and was also home of the Alabama Tobacco Company, which specialized in production of cigar wrapper tobacco. The first cars owned in Summerdale were owned by the tobacco company about 1900.

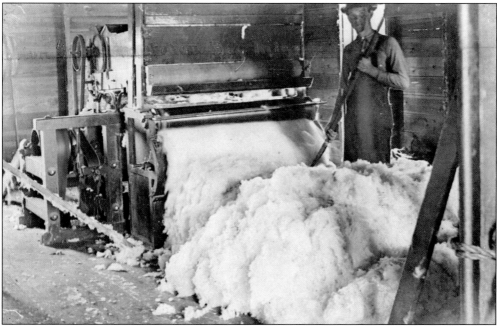

COTTON GIN. Cotton was not as much "king" in Baldwin County as in the Black Belt counties of Alabama. There were not many large antebellum cotton plantations, and the county was still thickly forested by 1900. It was a profitable crop, however, for many small farms in the 1900s as cleared land became good crop land. The gins remove the seeds and bale the cotton for shipping. Today cotton is a major cash crop.

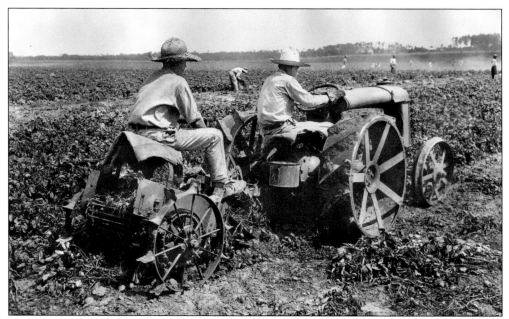

MECHANIZED FARM EQUIPMENT. Even though this early tractor is digging the potatoes, workers are on hand to pick up the potatoes and load them by hand into bags or baskets (today large plastic tubs are used) in the field and transfer them to waiting wagons and trucks. They are then taken to the potato shed for sorting and packaging into labeled burlap bags. (Courtesy of Foley Museum.)

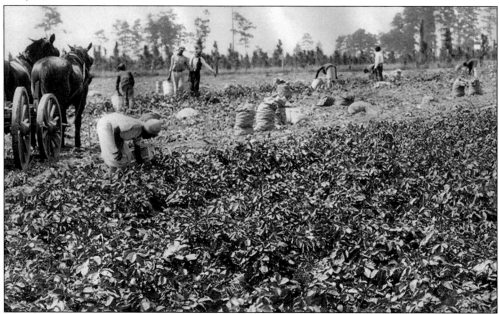

MIGRANT WORKERS. Migrant workers have also been major players in the potato crops in Baldwin County. Transient African American and Hispanic workers have long been regulars at many farms, and their children are schooled in the public schools during the work season. Many of these families have remained in the county. The photograph is labeled "Irish Potatoes Baldwin Co, May 17, 1926." (Courtesy of Foley Museum.)

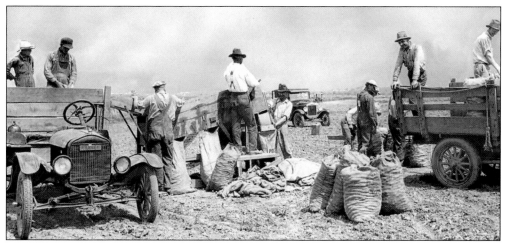

POTATO FARMS. "Irish Potatoes—Alabama Farm Company, May 15, 1926" is noted on the photograph. For most of its agricultural history, the county has been economically dependent on potatoes—Irish, red, and sweet potatoes, a side dish at every Southern meal. The Rhodes Farm in Bay Minette was one of the largest producers of potatoes, but the Cortes, the Lazaris, the Underwoods, the Cleverdons, the Underwoods, and the Childresses were also major producers of potatoes. The industry has historically been dependent on much human labor for its success. The plowing and planting of the potatoes begins in February, and they are harvested in April and May. School holidays (spring break) and summer vacation (beginning in early May) were usually scheduled to accommodate the need for student and family workers to be available for the planting and harvest.

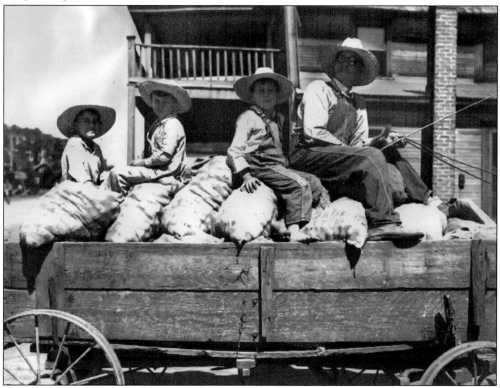

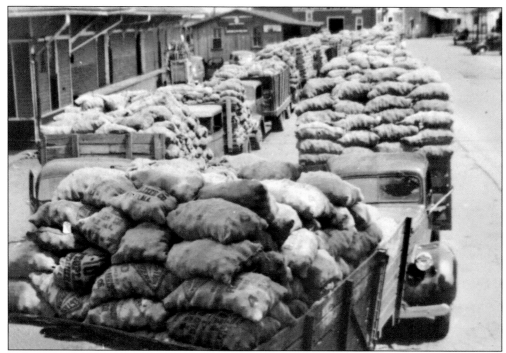

SHIPPING POTATOES. Potato sheds were located near every train yard. The Corte family had sheds in Loxley as well as Foley and employed many workers during the shipping season. Potatoes were graded, and the price depended on the quality and size of the potato. Red potatoes are the crop potato of choice now, especially as the early harvest enables a second cash crop on the same land. Farmers today often sell "new" red potatoes at curb market stands throughout the county, the bags of "field run" potatoes indicating they have not been sorted or graded. Extra trains were run during the potato season. Since the rail spur was discontinued, tractor trailer trucks are used.

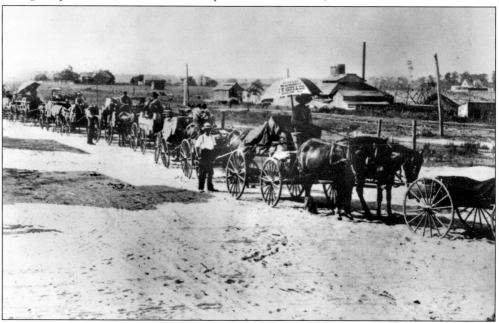

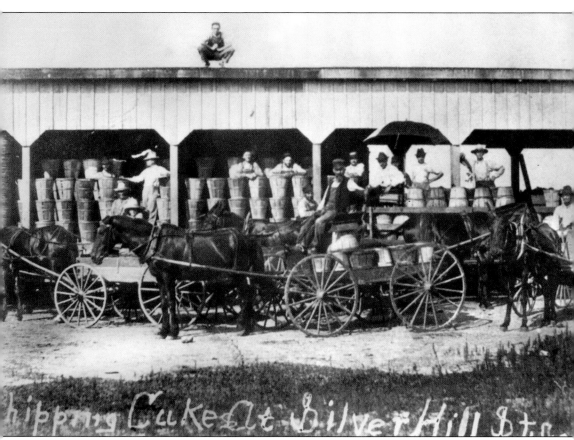

ROBERTSDALE CUCUMBER SHED. Robertsdale area farmers became known for their cucumbers perfect for pickling. Quite a valuable cash crop, cucumbers were grown in all varieties, sizes, and shapes and were shipped to canning and pickling factories in the North. Notice that most farmers were still using horses and buggies for transporting agricultural products to market even after they had a diesel tractor at home. The main canning factory in the county was at Summerdale. The cucumber season is long, making it desirable for small farm operations. Notice the photograph is labeled "Silverhill Station," which was actually the depot at Robertsdale.

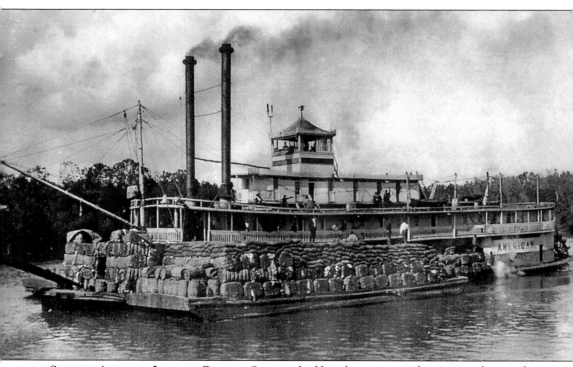

STEAMER AMERICAN LOADING COTTON. Steamers had long been seen on the rivers, with more than 200 landings on the Alabama River alone during the Golden Age of Alabama. The *American*, pictured here, did make stops in Baldwin County to load cotton but more for passenger stops, as there were few cotton plantations here during the era. As railroad travel became more prolific, the "Floating Palaces" began to be replaced. (Courtesy of Billy Slaughter.)

Seven

THE PEOPLE WHO CAME TO WORK

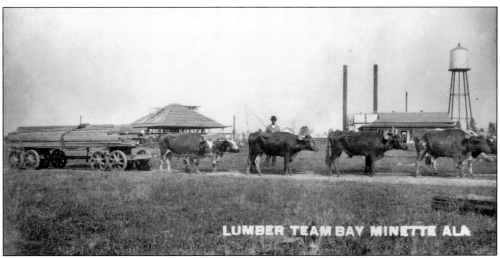

LUMBER TEAM. Early industries came to Baldwin County to support the forest and agriculture economy, answering the need for local farmers and lumbermen to market their wares. Common scenes in the north part of the county included ones like this lumberman driving his ox team pulling a load of milled lumber for a delivery. Independent team operators contracted with the mills to transport the logs and lumber.

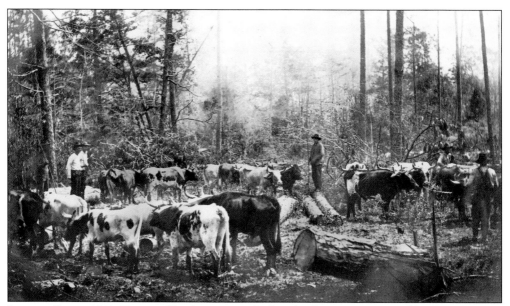

LUMBER CAMP, 1910. Teams of lumbermen worked in the forests, cutting and hauling the trees to mills by oxen teams or floating them downriver. They lived in camps for a week at a time, with the camp cook being the most indispensable employee. Leslie Smith in *Down From the Swamp* gives vivid details of life in lumber camps in the delta region. The sawyers, very skilled at felling the trees in the desired direction, yelled "Headache" rather than "Timber" as a tree fell. These pictures demonstrate the use of oxen for the heaviest work in the camps. Oxen were used long after motorized transportation was available because of the expense of maintaining trucks and loading equipment but primarily because of the difficulty of acquiring fuel in the remote areas of lumber camps.

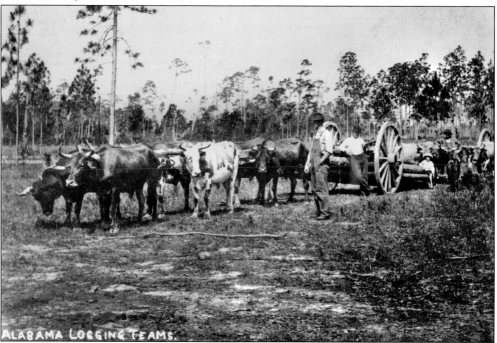

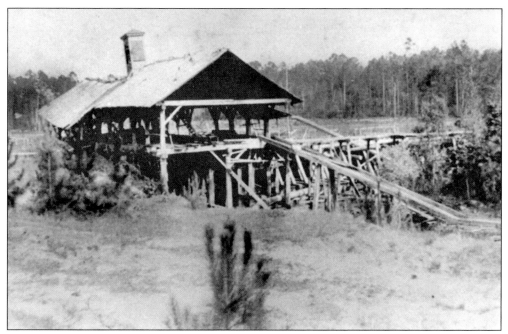

LUMBER MILL. In Stockton, the mill above was first owned and operated by Joseph Booth, who had come with Andrew Jackson to the Stockton area during the Native American uprising period. Logs were stripped, sawed into boards, and transported to Mobile for shipping or sales in the city. (Courtesy of Davida Richerson Hastie.)

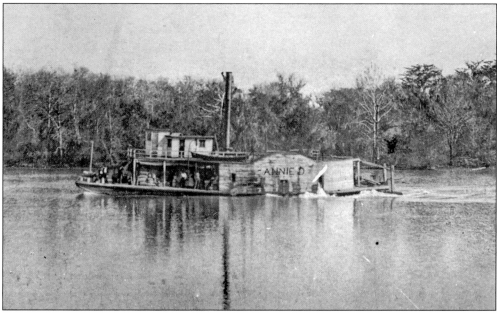

THE ANNIE D CARGO BOAT. Beginning in 1893, the *Annie D* was seen for 40 years transporting freight between Stockton and Mobile. She was a steam vessel 101 feet long with a draft of 5 1/2 feet. She was a two decker owned by B. F. McMillan and was used in the lumber industry as well as supplying businesses with orders, returning from Mobile with foodstuffs for lumber camps. (Courtesy of Davida Richerson Hastie.)

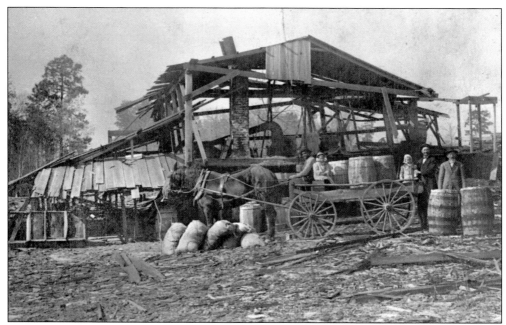

TURPENTINE DISTILLERIES. Trees were chipped by slicing a streak in the side. This scar, the face, made in the spring started the sap flowing into tin or clay cups. It was collected, put in barrels, and sent to the still. The chippings were distilled, producing resin, used like tar, and spirits of turpentine, used in paints and medicines. The bags in front of the wagon are "tar babies," the residue left after the straining of the resin, used as fire starter. Robertsdale was home to the large turpentine still pictured below in 1915. By 1939, there were at least 31 turpentine stills, with $700,000 realized annual profit. There were more than three million trees involved in the industry in the county, with only 20 men owning the land and the processing plants.

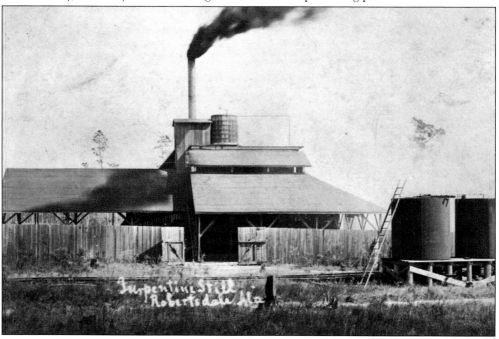

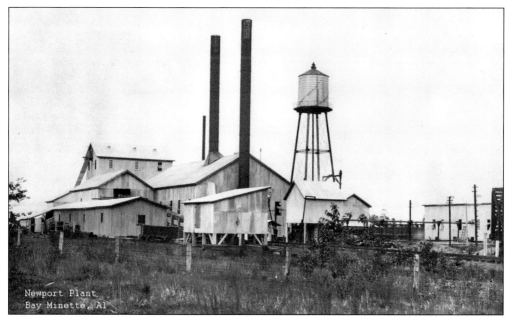

NEWPORT PLANT. In "the industry that pine knots built," Newport was a pale rosin plant employing 300 people in the Bay Minette area, as reported in the 1939 *Baldwin Times*. The plant—producing resin, turpentine, pine oil, and other products of the "tar plant" or pine tree—was begun in 1912 with about 100 employees. It was the largest county employer in 1939 with a monthly payroll of $10,000.

BACON-MCMILLAN CREW HOUSE. At one time, the largest business in Baldwin County was the Bacon-McMillan Veneer Plant. It was originally the Bacon Underwood Mill in Mobile, moving to Baldwin County when John McMillan became a partner. The plant made veneer of tupelo gum, with the men living on this floating camp. This camp in the 1930s was used for the pullboat logging crew. (Courtesy of Tom Sangster.)

ALLIGATOR HUNTER DISPLAYS HIS BOUNTY. Alligator lore holds the interest as no other stories can. The abundance of alligators throughout the county made hunting a profitable business for those who could wrestle them into submission. William Bartram noted a fascinating battle between two gators in his 1770 naturalist journals he wrote while on his famous canoe trip in the delta. However, the legend of "Two-Toe Tom" is one of the most beloved of tall tales in the South. The huge alligator had lost two toes in a trap, endowing him with uncanny powers for revenge. Rewards were offered for his capture, but he has eluded hunters to this day. One of the largest ever taken was in the Bon Secour River by the Cooper brothers and Henry Weeks, who fought for two days with the 1,000-pound, 13-foot monster. Alligators are no longer endangered but rather are quite prolific, and the very limited hunting season is held in late summer. This alligator hunter is preparing the skins for sale.

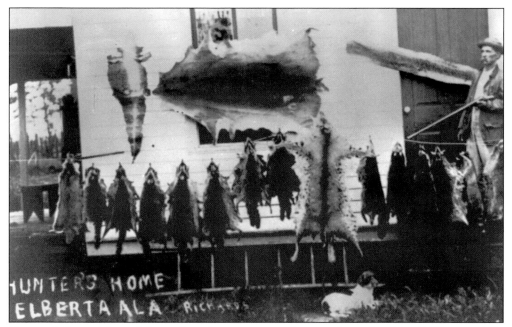

Trapper's Furs. Many of the earliest pioneers came to hunt and trap the rich wildlife, especially the earliest English and Scottish pioneers in north Baldwin. Stories of the plentiful wolves are told and of the Native American boy servant who could imitate a wolf cry so naturally he lured wolves into gunshot range of his master. Raccoons, fox, beaver, and deer were also trapped for furs.

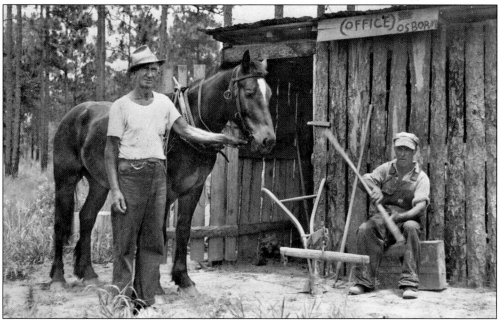

Blacksmith Shop. Blacksmiths were crucial in the success of all businesses. The blacksmith, according to Leslie Smith, was as much a carpenter as an ironworker. Rebuilding equipment was much more economical than the expense of purchasing new equipment, so the blacksmith was a necessity at every mill and logging camp, and in every town. Rebuilding a wheel required much precision, and the assembly required four men. This blacksmith shop was in Foley.

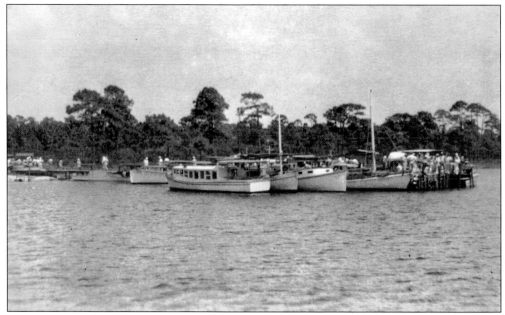

FISHING BOATS. The fishing, shrimping, and oystering industries in Baldwin County have been in operation since the earliest settlements in Bon Secour and Orange Beach were begun. Processing plants were located near the shores, but boys from Orange Beach took fish tied on the front of the school bus to Foley, stopped at the fish market to sell their catch, and then walked on to high school.

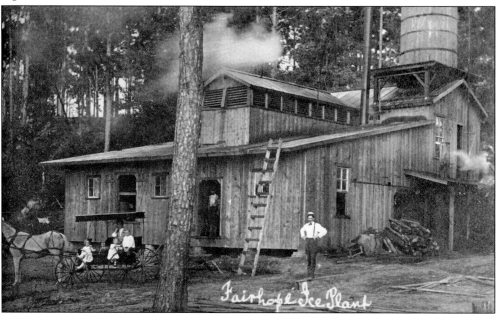

FAIRHOPE ICE PLANT. Adolph Berglin founded the Fairhope Ice and Creamery Company at the foot of Wharf Hill, later moving to the corner of Fairhope Avenue and Bancroft Street. Other ice plants and creameries were located throughout the county, as the dairy industry was a very prominent source of income. Berglin was mayor of Fairhope and began the annual Fourth of July fireworks extravaganza.

Eight

THE PEOPLE WHO CAME TO TEACH

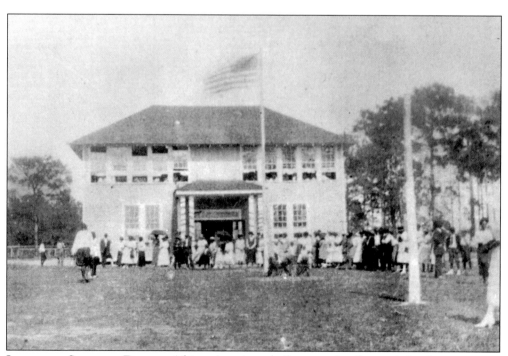

INDUSTRIAL SCHOOL IN DAPHNE. African Americans built many schoolhouses in local communities, but Rev. S. B. Bracy and the Eastern Shore Missionary Baptist Association in 1889 had a much larger vision. The Eastern Shore Baptist Academy for Negroes was built in Daphne by the association and remained a private school until it was deeded to the public school system in 1915. It then became the Eastern Shore Industrial School, grades one through nine.

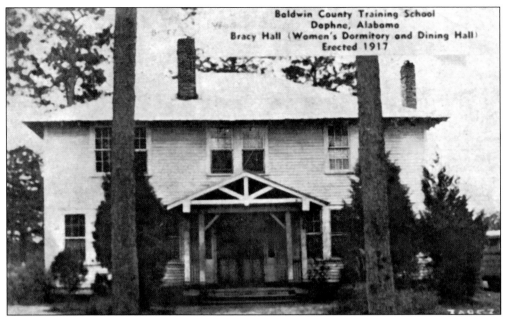

GIRLS' DORMITORY. In 1927, the school was named Baldwin County Training School, and it remained the only black high school until 1950. There were 14 Rosenwald schools throughout the county for grades one through seven. High school students living in outlying areas could board at the Daphne school; this photograph is of the girls' dormitory and dining hall. (Courtesy of Gartrell Agee.)

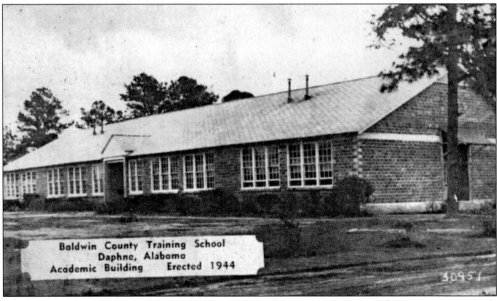

BALDWIN COUNTY TRAINING SCHOOL. This 1927 building served all the African American high school students in the county until the Douglasville and Aaronville schools were expanded to 12 grades. In 1972, the school became the integrated Daphne Junior High School. The W. J. Carroll School continues to educate community children on the same site, and the remaining 1939 vocational building houses the Museum of African American Education. (Courtesy of Gartrell Agee.)

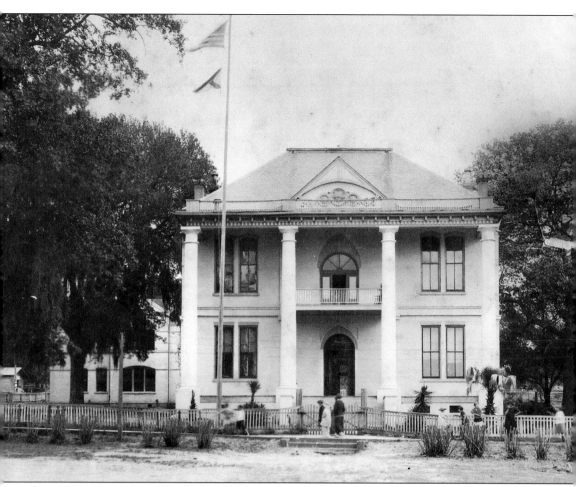

STATE NORMAL SCHOOL. The Daphne building that had housed the courthouse in the 19th century was given new life as a most respected teachers' college, the Alabama State Teachers College on Mobile Bay, or, as most people knew it, the Daphne State Normal School. The teachers in Baldwin County petitioned the state legislature to endorse a public school in the building rather than sell the property, and on July 4, 1907, the normal school was founded, with the agreement that the state would provide $2,500 and there would be $10,000 in local subscriptions. Dr. J. Lovett was elected the first president and issued a catalog announcing the school opening in October 1907. The catalog outlined courses of study and boarding arrangements and gloriously detailed the natural scenery, perfect drainage, clear drinking water, and charming climate. The building was altered slightly about 1918, extending the lower porch all the way across the front of the building and installing four large round columns in the front. The inside spiral iron staircase was moved to the back porch. (Courtesy of Daphne Museum.)

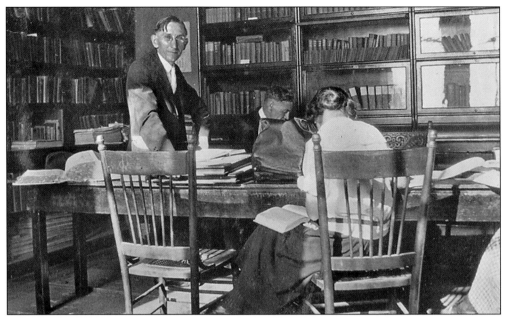

PRES. B. B. BAKER. The second president of the Daphne State Normal School was Dr. Bertsil Burgess Baker, whose directorship for seven years created an institution known for preparing teachers in exemplary fashion. The school was an elementary and high school for the community and a two-year teacher preparatory school. Dr. Baker's wife, Bonnie, is credited with founding many of the community societies such as the Lyceum to enrich culture in the lives of citizens.

DR. H. H. HOLMES. Hilary Herbert Holmes was from Tensaw, his grandfather having survived the Fort Mims massacre. He completed several college degrees and was elected to the Alabama Senate. He and his wife, Christine, moved to Daphne in 1915 as he became third president of the school. This photograph of Dr. Holmes with his three children was taken shortly after the death of his wife, for whom the entire community grieved deeply.

CLASSROOM BUILDING. The jail became the model school for grades one through seven, taught by students in the teacher training program. Secondary students were taught by college professors and student teachers. County teachers met there each school year for annual "Institute" instruction from the superintendent. J. S. Lambert, Aubrey McVay, and R. Leslie Smith were all associated with the Daphne State Normal School before becoming county school superintendents. (Courtesy of Daphne Museum.)

MAY DAY COURT. Longtime residents of Baldwin County have memories of countywide May Day celebrations at the Daphne State Normal School. The president's wife, Bonnie Baker, initiated a festival of garlands, and a queen, Isabel Goldsby, was crowned that first May Day, 1911. In 1912, King Dan Long crowned Queen Edna Childress. Soon the event grew countywide, with all county schools represented in the court. (Courtesy of Daphne Museum.)

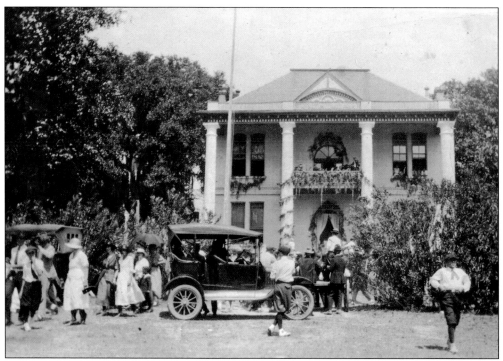

MAY DAY CELEBRATION. The 1922 *Nymph*, the school yearbook, details the account of the thousands who enjoyed the booths, speeches, athletic meets, ball game at Dryer Field, and band music all day. The operetta *Windmills of Holland* was a resounding success, and "Myrtle Owen, the Queen of May, was as fair as the lily placed in her hand as a wand." (Courtesy of Daphne Museum.)

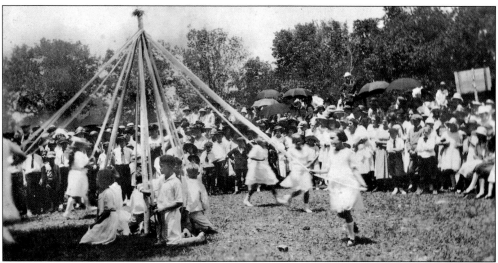

MAYPOLE TRADITION. A maypole was danced and wound many years under the direction of Pauline Thompson. Other dances were performed, and the queen and court were presented followed by a barbecue dinner. A 1912 account records "horse races, a baby show, a track meet, and a ball game with Bay Minette, in which Daphne was victorious." The oak grove is today May Day Park in Daphne. (Courtesy of Daphne Museum.)

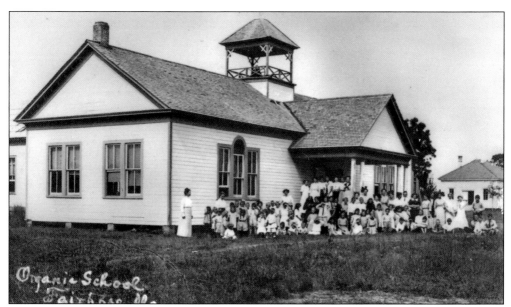

THE BELL BUILDING, ORGANIC SCHOOL. One of the most outstanding examples of educational innovation and progressive thought is the Marietta Johnson School of Organic Education in Fairhope. The school was widely known for the educational philosophy of Johnson, who came to Fairhope in 1906 at the encouragement of Lydia Comings. The Bell Building was her first classroom building and is today the Marietta Johnson Museum. (Courtesy of the Marietta Johnson Museum.)

MARIETTA JOHNSON. John Dewey was among the famous visitors who came to observe an educational program designed to reach the "total child." The school was non-traditional, as there were no fixed desks and there were many life skills and service projects. Johnson did not believe in formally teaching reading until the age of eight or nine, according to the readiness of the child. (Courtesy of the Marietta Johnson Museum.)

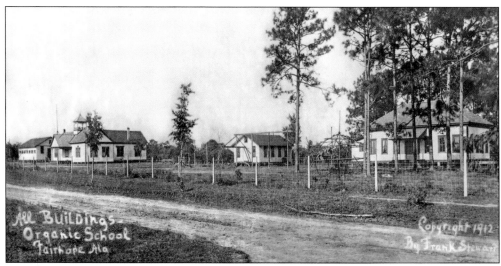

ORGANIC SCHOOL CAMPUS. The Single Tax Colony of Fairhope endorsed Marietta Johnson, and the large school campus was a result of the funds raised by the Johnsons. The school was open to all students in Fairhope, whether they could pay the tuition or not, and many times, class activities took place outside, either here on campus or in nearby gullies, woods, beachfront, or town. (Courtesy of the Marietta Johnson Museum.)

DRAMATIC PRODUCTION. Knowledge of the arts was a focus of organic education. Folk dancing became a trademark of student performances. The high-quality pottery pieces done at the school are collectors' items today. The patriotic production pictured above is an example of the extensive use of drama as a teaching tool. (Courtesy of the Marietta Johnson Museum.)

Nine

THE PEOPLE WHO HAD TIME TO PLAY

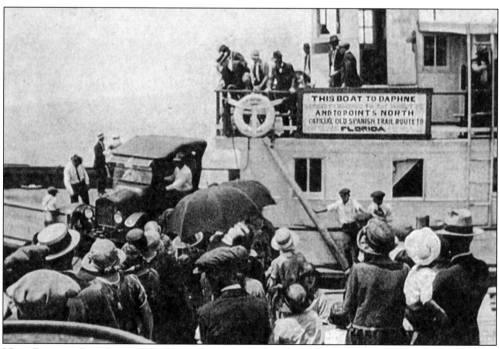

NEW DAPHNE BAY BOAT. The lure of the pleasures of the coast has been a powerful force in attracting people to the Eastern Shore of Mobile Bay. Bay boats such as the *New Daphne* were often filled with Mobilians coming to spend a day or more on the Eastern Shore. Stockton residents tell of their parents going to Daphne for the day by catching the train at Carpenter's Station, going to Mobile, then catching the *New Daphne* to the Eastern Shore.

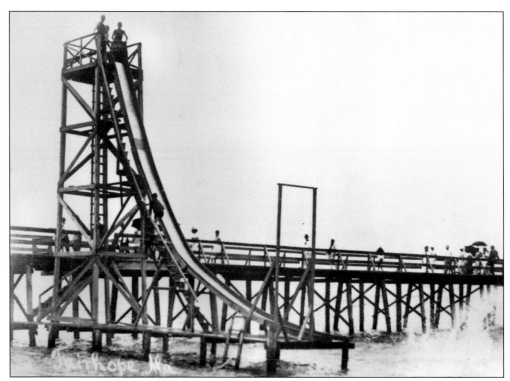

FAIRHOPE BAYFRONT MECCA. Fairhope's public beach brought residents and visitors alike to the entertainment area known as "The Pier." The brackish water of the bay made bathing in the warm waters a delightful experience, and the city offered much outdoor entertainment to be enjoyed by all. The high slide towered above the pier and ended in the water of the bay, usually only about 5 feet deep at this point. Bay boats docked at the end of Fairhope pier, which was equipped with rails to help load and unload baggage. Automobiles could be driven on the pier, and there was a horse-drawn wagon to help people up the hill to town.

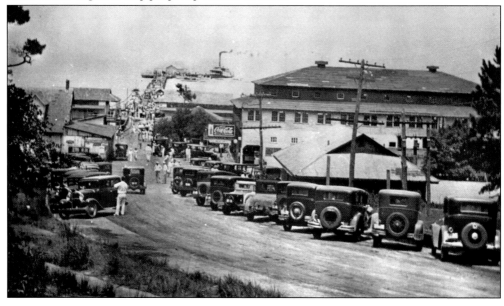

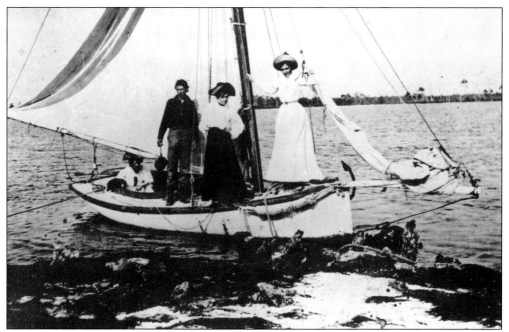

WELL-RIGGED SLOOP. An early news reporter used the caption "A Well Rigged Sloop" to illustrate an article touting the pleasures to be had on the bay in Baldwin County. Sailing as sport and pleasure was a major form of entertainment for those who could afford it. The ladies shown here are dressed for an outing on the water during this era.

THE *FALCON* EXCURSION BOAT. Sightseeing boats were also numerous and prosperous with the tourist trade. The *Falcon* is an example of boats for hire to explore the waterways, mainly the rivers and bays. These boats could make landing near the shallow docks and beaches. Many resort hotels offered sailing excursions to their guests.

BATHING IN THE BAY. Orange Beach was soon a destination for pleasure seekers who arrived by boat or by the rough road. Before the canal and bridge were completed, many boaters arrived at Orange Beach by way of Miflin. The waterfront businesses included the post office, a hotel, and a general store. It was considered healthy to expose the body to the water in Wolf Bay.

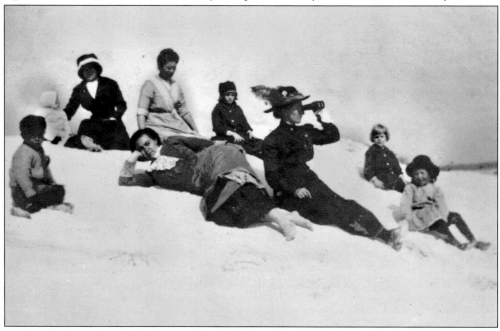

GULF SHORES SUN BATHERS. Sunbathing on the sugar-white beaches of Gulf Shores is enjoyed by members of the Bergman family in 1914. Gulf Shores is connected to the peninsula leading to Fort Morgan. Many times, automobiles drove along the shore on the packed sand, as that was more accessible than the primitive road to Fort Morgan.

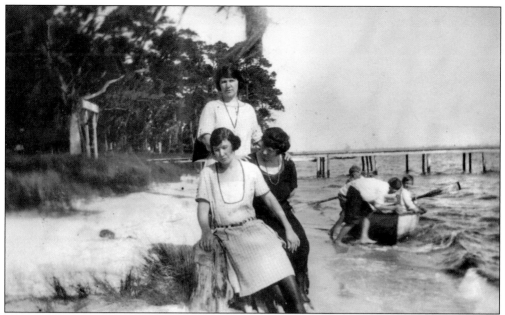

JOSEPHINE BEACH. Lovely teenage ladies Isabelle Ballard (seated in front) and two friends pose for a charming photograph on the shores of their home at Josephine. Her brother Austin is the boy pushing the rowboat into the waters of the Arnica Bay, a part of the larger Perdido Bay. (Courtesy of Lillian Ballard.)

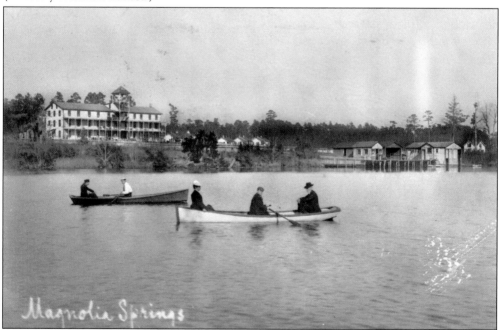

MAGNOLIA SPRINGS HOTEL. The many rivers in Baldwin County made rowing a most enjoyable excursion for an afternoon of leisure. Fish River, Magnolia River, and the Styx River are easygoing waters encouraging pleasure boating. These ladies were most likely staying at the Woodbound Hotel in Magnolia Springs and spent the afternoon on the water. This photograph was used as a postcard mailed from Magnolia Springs.

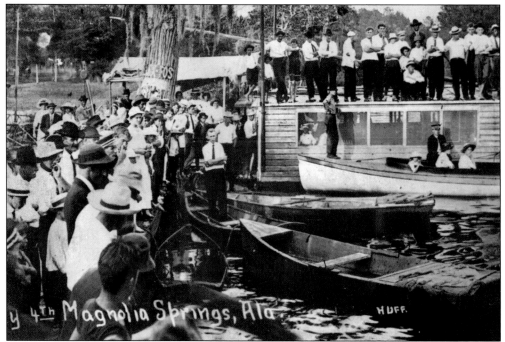

THE FOURTH OF JULY AT MAGNOLIA SPRINGS. A supply boat based in Magnolia Springs was the *Riley W.*, which was noted in 1911 to have just returned from New Orleans with a cargo of 6,000 watermelons for the Fourth of July celebration. The celebration of the Fourth of July was one of the main community events in the county. Magnolia Springs hosted a boat parade and watermelons for all after the political speeches.

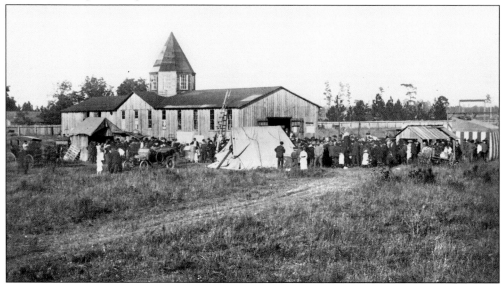

THE BALDWIN COUNTY FAIR AND RACING ASSOCIATION. An organization of farmers and businessmen of Bay Minette incorporated to promote advances in agriculture and to "incite a friendly rivalry and a judicious comparison" of products and livestock breeding. Many farmers owned stock in this organization and participated in the events held on the grounds and buildings of the association. Horse racing was a part of the annual fair held each fall.

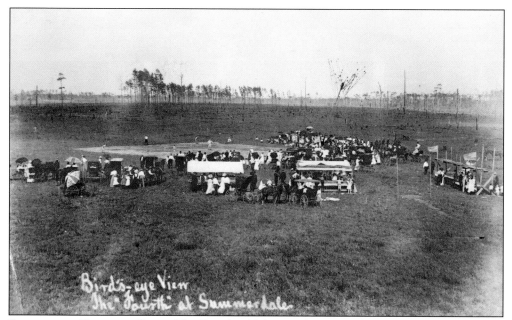

SUMMERDALE BASEBALL GAME. The Fourth of July was the most celebrated holiday during the 20th century. Every community hosted a display, a fair, public performances, entertainment, and general fun for residents and visitors alike. The Fourth of July at Summerdale was celebrated at the baseball field. Every town had its baseball team, and there was fierce rivalry and intense competition. The label on the photograph reads, "Bird's-eye View, The Fourth at Summerdale."

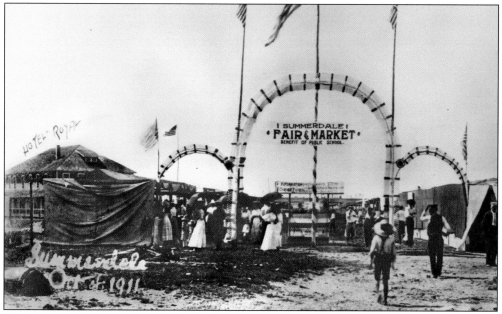

SUMMERDALE COUNTY FAIR. The highlight of the year for members of the 4-H Clubs and agriculture and home economics classes in schools was the annual county fair. The banner in the photograph reads "Summerdale Fair and Market Benefit of Public School." Hotel Royale is labeled in the background, and "Summerdale October of 1911" is also inscribed. Early county fairs served the purpose of livestock sales as well as judging events.

Coca-Cola Truck, Daphne. Leslie Lowell was the Coca-Cola salesman for many years in the county. This truck is photographed in Daphne in 1933 with his son Carrol ("Doodlebug") Lowell. His route assistant was John Mims, who later became the first African American person elected to public office in Daphne. (Courtesy of Daphne Museum.)

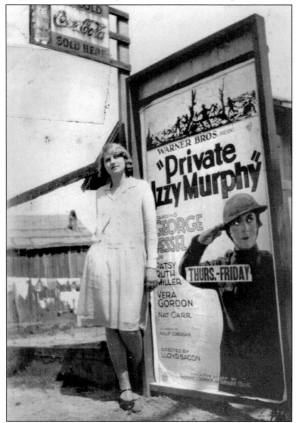

Movies. By the second decade of the century, there were movie theaters in almost every town. The Magnet Theater in Fairhope operated until the 1970s. The Dixie Theater, owned by J. M. Broadus, was in Bay Minette. Harriet Coon (Brill) is shown at a poster for a picture show there in 1926, *Private Izzy Murphy*, a silent film starring George Jessel and Patsy Miller.

BEAR HUNTING. Being a county so close to the earth, hunting camps have always been located throughout the northern parts of the county. Black bears were not endangered early in the 20th century and were hunted for their meat and fur. Tom Gause of Stockton is pictured at right as a small boy at the hunting camp where the men had a successful hunt. (Both courtesy of Davida Richerson Hastie.)

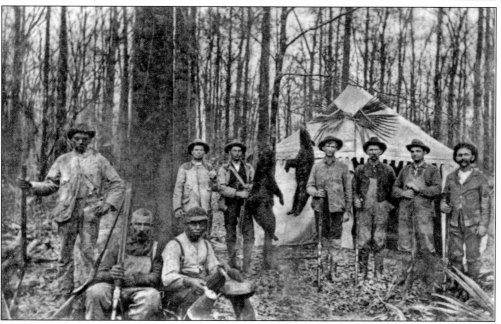

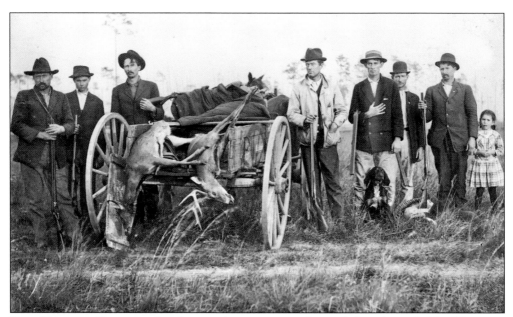

DEER HUNTING. Deer were abundant, as they are now, and provided much-needed food for many families. Deer hunts were organized in late fall, and the racks were shown as trophies in homes and lodges. Bird hunting was a winter sport, with Mixon's Winchester Store in Bay Minette advertising as a "local headquarters for all hunting paraphernalia except dogs."

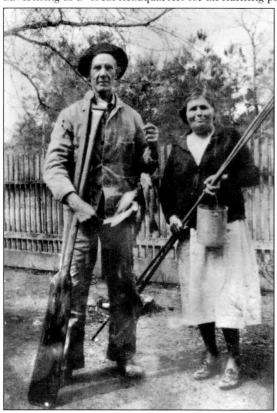

GOING FISHING IN THE DELTA. Ed Hammond and his wife, Emma, are heading out in a double-ender boat to go fishing in the delta. She is holding her trusty poles, and Ed has a paddle (not an oar), as recognized by the handle design. The Hammond family had operated the stagecoach inn in Stockton, shown on page 32. A pattern for building an authentic double-ender is in *Gone to the Swamp* by Leslie Smith.

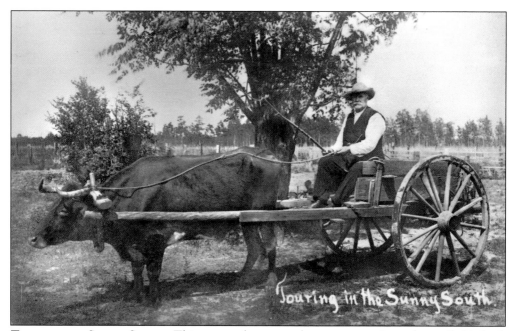

TOURING THE SUNNY SOUTH. This postcard was popular among tourists, who mailed it back home as a representation of the primitive lifestyle in Baldwin, emphasizing that Baldwin County remained mostly untouched by the rapid progress of industrialization. The photograph was made near Fairhope and shows a Mr. Bishop in his oxcart.

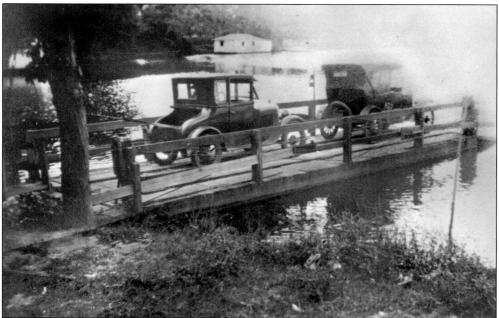

MARLOW FERRY. With the increase of automobiles and roads, touring the sunny South became even more popular. Many families spent Sunday afternoons driving country roads, perhaps crossing Fish River on this ferry at Marlow. Those drives through a rural countryside with stops at local dairies for ice cream may be lost in this time we call progress, but they will never be forgotten if they are told and remembered.

BIBLIOGRAPHY

Allums, Larry. *Fairhope 1894–1994*. Virginia Beach, VA: The Donning Company, 1994.

Baldwin County Heritage Book Committee. *The Heritage of Baldwin County, Alabama*. Clanton, AL: Heritage Publishing Consultants, 2001.

Brill, Harriet. *A Nickel's Worth of Baloney*. Mobile, AL: University of South Alabama Press, 1993.

Buskens, Joy Callaway. *Well, I've Never Met a Native*. Columbus, GA: Quill Publications, 1986.

Comings, L. J., and Martha M. Albers. *A Brief History of Baldwin County*. Fairhope, AL: Baldwin County Historical Society, 1928.

Crosby, Samuel N. *The Sleeping Juror*. Montgomery, AL: Alabama Law Foundation, Inc., 2002.

Crowder, Joan White. *Tell It to an Old Hollow Log*. Bay Minette, AL: Lavender Publishing, 2000.

Long, Margaret Childress, and Michael D. Shipler. *The Best Place to Be: The Story of Orange Beach, Alabama*. Bay Minette, AL: Leedon Art, 2008.

Rich, Doris. *When Foley Was Very Young*. Foley, AL: self-published, 1983.

Scott, Florence, and Richard Scott. *Daphne*. Bay Minette, AL: Lavender Press, 2003.

Smith, Robert Leslie. *Gone to the Swamp*. Tuscaloosa, AL: University of Alabama Press, 2008.

Stoddard, Tom. *Foley Steps Forward*. Foley, AL: City of Foley, 2001.

Taylor, Vivian McCreary. *Backtracking the Wood Tick Trail*. Bay Minette, AL: Lavender Publishing, 1998.

INDEX OF SETTLEMENTS

In 1939, the *Baldwin Times* reported that Baldwin County had the highest percentage of foreign-born citizens of all 67 Alabama counties. The following list records the settlements documented in this work.

African American—Daphne, Vaughn, Point Clear, Bay Minette, Foley
Amish—Bay Minette
Bohemian—Silverhill, Summerdale
Creek Indian—Little River
Creole—Bon Secour, Magnolia Springs, Fairhope
Croatian—Dyas
Czechoslovakian—Perdido
Danish—Silverhill
English—Blacksher, Stockton
French—Daphne, Bon Secour
German—Elberta, Rosinton
Greek—Malbis
Italian—Daphne, Belforest
Irish—Silverhill
Lebanese—Bay Minette
Lithuanian—Summerdale
Mennonite—Summerdale
Mexican—migrant camps
Polish—Summerdale
Quaker—Fairhope
Scottish—Little River
Single Tax Colonists—Fairhope
Spanish—The Village, Spanish Fort
Swedish—Silverhill, Summerdale
Yugoslav—Dyas

DISCOVER THOUSANDS OF LOCAL HISTORY BOOKS
FEATURING MILLIONS OF VINTAGE IMAGES

Arcadia Publishing, the leading local history publisher in the United States, is committed to making history accessible and meaningful through publishing books that celebrate and preserve the heritage of America's people and places.

Find more books like this at
www.arcadiapublishing.com

Search for your hometown history, your old stomping grounds, and even your favorite sports team.

Consistent with our mission to preserve history on a local level, this book was printed in South Carolina on American-made paper and manufactured entirely in the United States. Products carrying the accredited Forest Stewardship Council (FSC) label are printed on 100 percent FSC-certified paper.

MADE IN THE USA